YOU CAN
DRAW

David Brown

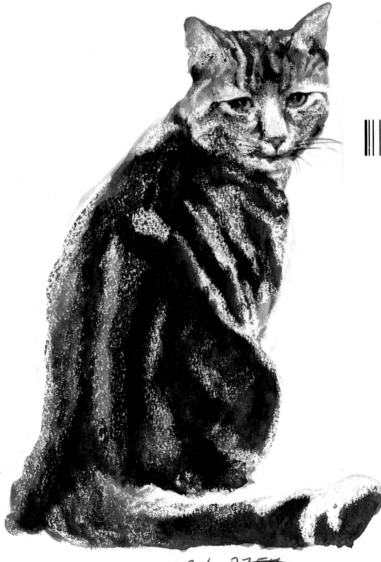

D1303425

First published in 1986
by William Collins Sons & Co., Ltd
London · Glasgow · Sydney
Auckland · Toronto · Johannesburg

First published in the United States in 1987
by North Light Books,
an imprint of F & W Publications, Inc.
1507 Dana Avenue, Cincinnati, Ohio 45207

© David Brown 1986

Designed by Caroline Hill
Colour reproduction by Bright Arts, Hong Kong
Photography by John Evans

ISBN 0–89134–216–8

Printed and bound in Italy
by New Interlitho SpA, Milan

CONTENTS

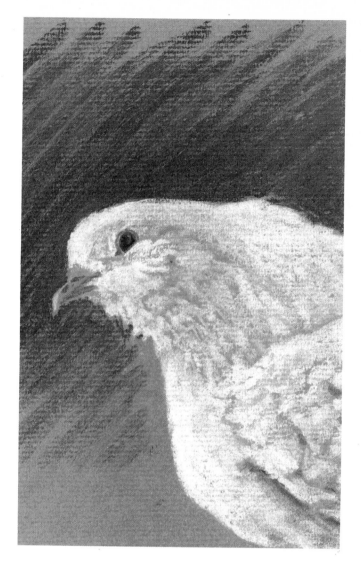

Brush drawing (*opposite*) of a dog's skull
Drawing of a dove (*above*), using pastels and coloured pencils

PORTRAIT OF AN ARTIST
DAVID BROWN MSIAD

Fig. 1 David Brown at home in Shenfield

David Brown was born in Llanelli, Dyfed, South Wales, in 1932. His drawing ability was recognized at an early age by his parents, who encouraged him by buying him sketchbooks, pencils, ink and books on drawing, but it was the family doctor who suggested to his parents that David should develop his talent by going to the local art school. It was then, while still at school, that he attended the Llanelli School of Art every Saturday morning. At the age of fifteen he passed a bursary examination which enabled him to leave school and attend the art school on a full-time course. He studied there for four years, supplementing his grant by working in the holidays, during which time he passed the Intermediate Art Examination with distinction. Some of his work was exhibited at an exhibition of work from Welsh art schools in Cardiff and prompted a letter from Sir David Eccles, an art connoisseur and then Minister of Education, expressing interest in his future.

However, David's studies were interrupted in 1952 by National Service. He joined the Royal Welch Fusiliers and on finishing his basic training joined the 1st Battalion in Jamaica where he proved to be a marksman with the rifle and was consequently recruited into the battalion rifle team. He served in Jamaica for over a year before the battalion returned to Britain and then transferred to Dortmund, W.

Germany. On completing his service in 1954, he returned to his home town where he worked for a year before successfully applying for a place at the Central School of Art in London. He studied there for two years.

In 1957 David joined an advertising agency in London as a visualizer where he worked for eighteen months before joining a design group, eventually becoming a director and a member of the Society of Industrial Artists and Designers. In 1960 he went into partnership and formed his own design group, and after several years went solo, working as a freelance illustrator and designer. At present he works for a variety of design groups, advertising agencies and publishing firms in and around London, and his work has been produced in a variety of design annuals, including the international *Graphis Annual. Learn to Draw* is his sixth book on drawing: others cover subjects such as perspective, and drawing birds, cats, horses and wild animals.

Apart from drawing, his main interests are rugby, which he played at school and while serving with the Royal Welch Fusiliers, antiques and history. He is also interested in metal detecting.

David Brown now lives in Shenfield, Essex, with his wife and son, who has recently graduated in Graphic Art & Design.

Fig. 2 Using his wife as a model

Fig. 3 Drawing plants in his garden

INTRODUCTION

Everyone has the ability to produce a drawing, although by that I don't mean that everyone can necessarily draw well. Most people at some time or other have tried drawing. For many of us this occurred when we were at school, but the great pity is that the majority, on leaving, never attempt to draw again. There may be several reasons for this: sometimes art teachers fail to encourage and interest their pupils sufficiently in the subject; sometimes pupils regard the art lesson as a period for 'playing around' in between the history and maths lessons; or perhaps there's the feeling that one has not enough time to devote to drawing. On the other hand, it may simply be a question of a lack of confidence.

With respect to drawing, some fortunate people are gifted, while others have difficulty producing an acceptable drawing – but all have the ability to produce *some* kind of a drawing. So from this beginning it follows that everyone, with guidance, can improve. Never feel that you are too old to start. I should point out here, to reassure you, that a good drawing need not be highly detailed. Excellent drawings have been, and are being, produced which appear to be quite simple in content.

Ideally, beginners need someone at their side to teach them the basic rules of good draughtsmanship and instruct them how to observe and use that observation intelligently. But, alas, it is not always possible or convenient to attend a class where you would have a tutor at hand to help you and answer your questions. Which brings me to the reason for writing this book. In it I will point you in the right direction, by explaining the rules of perspective, how to work out proportions, how to cope with light and shade, what materials are available, the effects they produce, and how to use them to acquire those effects. I have kept things simple by keeping to single figures and objects wherever possible. Many of you will want to learn to draw simply for your own enjoyment. But others, such as designers, visualizers, architects, or those who produce newsletters, information sheets, leaflets or posters for their clubs or societies, may feel they need to raise the standard of their drawing ability in order to improve the presentation of their work. Whatever your reason for learning to draw better, I hope this book will prove helpful to you.

As with all skills, practice is a great improver, so draw as often as you can. Carry a small sketchbook so that whenever you have a spare moment and see some-thing of interest, you will be able to make a drawing of it there and then.

Use your materials freely and don't think to yourself, 'This is going to be the best drawing that I have ever done', because this will immediately cause you to tighten up and try to draw neatly. As a result you will think more and more about *how* you are drawing and not *what* you are drawing. Relax, just draw, and improvement will come.

So let's enjoy ourselves. Play around with different media until you find one that you feel most comfortable with, but please do work in as many media and combinations of media as possible. Use lipstick or soap if you feel that way inclined! Remember, there are no rules where media are concerned; the choice depends on the suitability for the effect you wish to achieve.

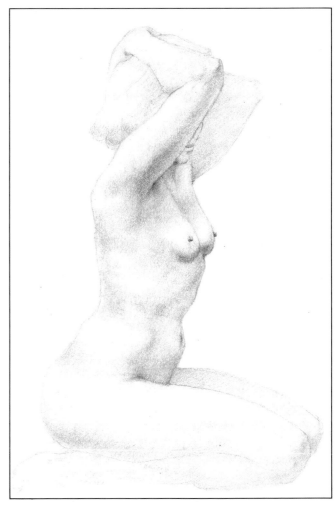

Fig. 4 Pencil drawing on cartridge paper

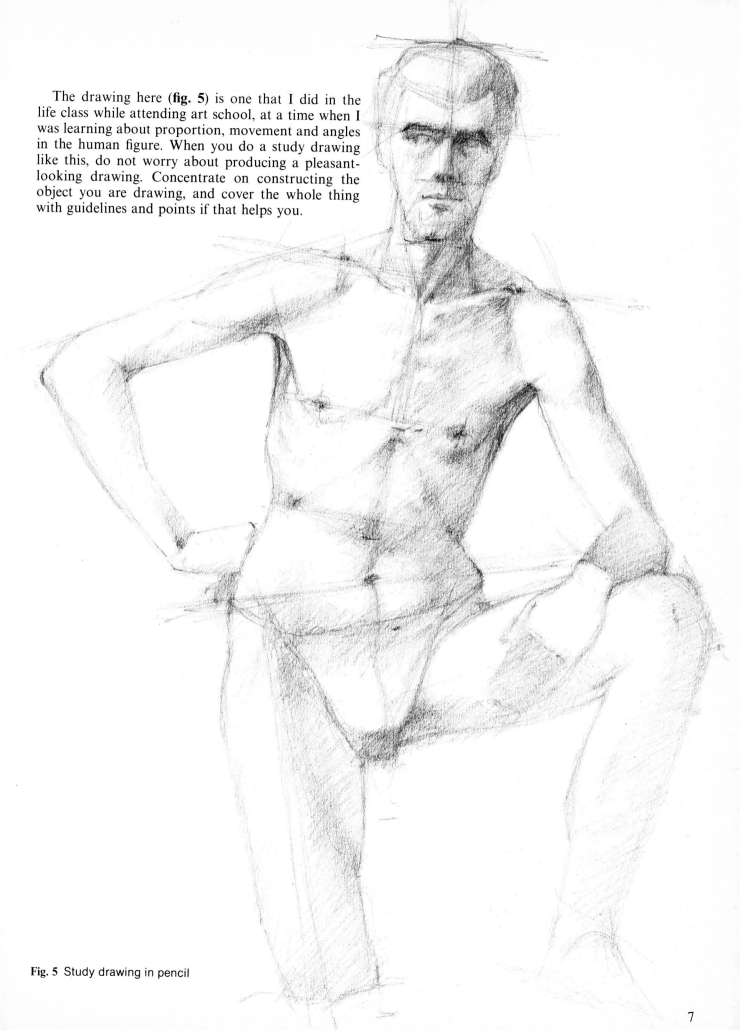

The drawing here (**fig. 5**) is one that I did in the life class while attending art school, at a time when I was learning about proportion, movement and angles in the human figure. When you do a study drawing like this, do not worry about producing a pleasant-looking drawing. Concentrate on constructing the object you are drawing, and cover the whole thing with guidelines and points if that helps you.

Fig. 5 Study drawing in pencil

WHAT EQUIPMENT DO YOU NEED?

There is such a vast range of materials which one can purchase that it is not surprising the beginner becomes confused as to what exactly to buy. In this section I will describe the different types of materials and illustrate some of the effects which they produce. Remember to buy the best that you can afford – it will make working easier and less frustrating. Materials of quality won't make you a better artist, but they will help you to avoid the discouraging frustration of trying to cope with, for example, a poor-quality brush that annoyingly spreads its bristles each time you place it on the paper; or the pencil that contains grit in the lead, thereby preventing you from producing a flowing line or subtle shading. Start by buying the materials which interest you most; you can gradually add to them later, as and when your enthusiasm and finances allow.

Experiment with your materials as much as you can to get the feel of them and discover what they can and cannot do. At first you do not have to draw anything in particular; just cover the paper with doodles. Sharpen your pencil to a fine point, then to a chisel edge, and see what difference this makes. When working in ink, dab the ink on the paper with your finger when it is still wet to discover the effect this produces, or dampen the paper before drawing on it. How about dipping the *handle* of your brush into the ink and drawing with that (see page 39)? Try using pastels in their purest form – that is, in their original colours and tones – instead of mixing them; but then do exactly that: mix them to produce other colours and tones. Which effect do you prefer? Now try rubbing the colour with your finger, either grading it into colour or into the paper itself. Use a blending stump to produce the same effect. Try the pastels on different coloured papers, even blotting paper or sandpaper if you like. Use a kneaded eraser to pick out highlights, light lines, and so on (see page 35).

What I am saying is, don't be restricted by what you think is the obvious use of a particular medium; experiment with it, push it to its limits. You could be pleasantly surprised at the results. This applies to all media and until you have experimented like this you will never really know what effects can be produced. Don't be afraid to mix one medium with another either. **Fig. 6** illustrates the range of drawing materials available, and these are described in detail on the following pages.

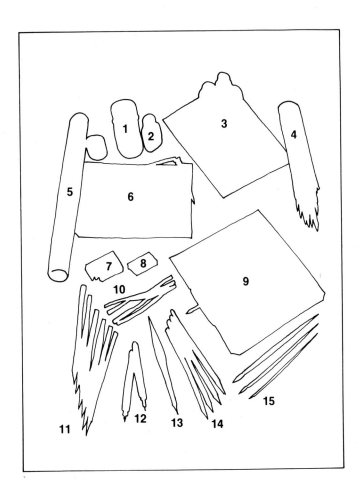

Key to **Fig. 6**

1 Aerosol fixative
2 Masking fluid
3 Coloured drawing inks
4 Coloured pencils
5 Brush case
6 Beginners' set of pastels, fixative, spray atomiser
7 Kneaded eraser
8 Eraser
9 Combination watercolour box
10 Charcoal
11 Pastel pencils
12 Technical pens
13 Drawing pen
14 Pencils (see also **fig. 7**)
15 Sable brushes (see also **fig. 16**)

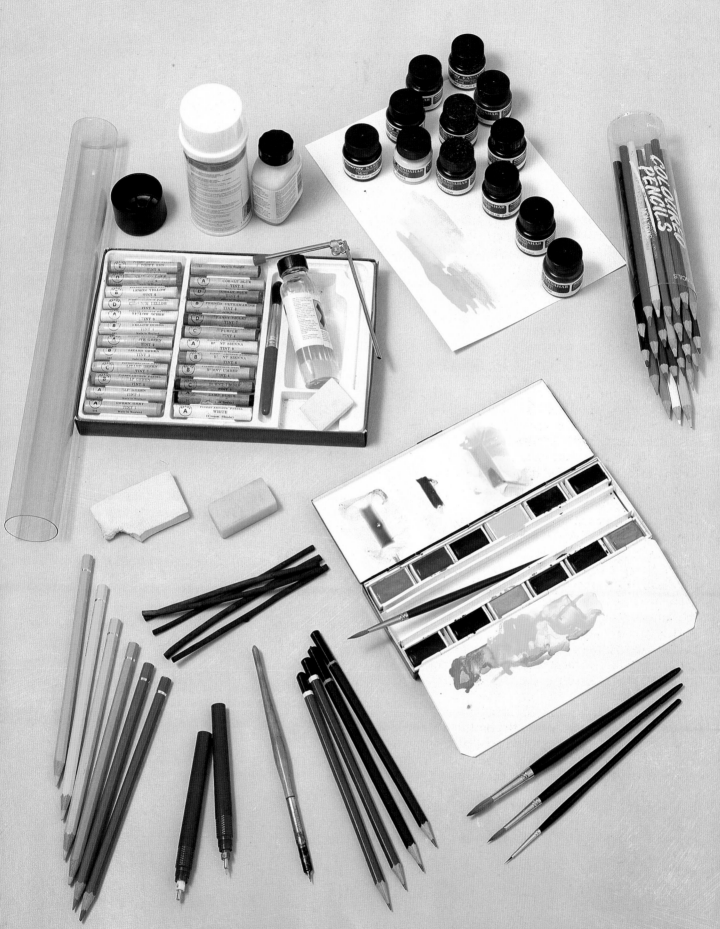

Fig. 6 A selection of drawing materials

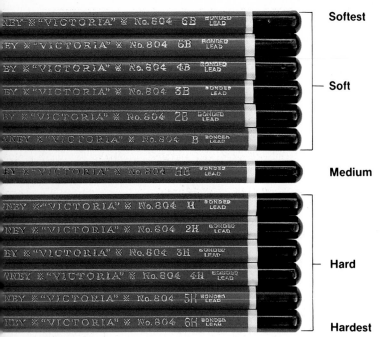

Softest

Soft

Medium

Hard

Hardest

Fig. 7 The range of pencils

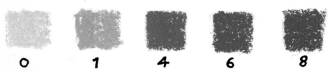

0 1 4 6 8

Fig. 8 Pastel tints

Fig. 9 Pastel stick and pencil

Fig. 10 Charcoal sticks and pencil

Pencils

It is surprising how many people do not realize what a range of leads can be found in pencils. In fact, there are at least thirteen, ranging from very hard to very soft. In the middle of the range is the HB pencil; from there the range goes in two directions – along the Bs for soft and along the Hs for hard. The higher the figure the harder or softer the pencil, depending on whether it is H or B (**fig.7**), and the lighter or darker the resulting lines.

Sharpen your pencil carefully to a fine point if you are doing detailed work, using a pencil sharpener, and keep sharpening it as you work. For work of a freer and bolder nature you need not have such a sharp point, and for broad work you can sharpen your pencil with a blade to chisel shape. In each case you should make sure that the pencil tapers to a long point, with the exposed lead well clear of the wood, otherwise there is a danger of the wood being dragged over the surface of your drawing and disfiguring it.

Pastels

There is an enormous range of pastels, consisting of fifty different colours and with several tints available in each colour. Pastels are graded from 0 (the palest) to 8 (the darkest), as illustrated in **fig. 8**. My advice is to start with a box of twelve or twenty-four and see how you get on with them. Single pastels can be bought later to add to the range or replace the ones used. You can buy a 'Beginners' Kit' consisting of twenty-four assorted colours, a dusting brush, a bottle of fixative (extremely useful for protecting your drawings and preventing them from smudging when they are transported from one place to another when you are out sketching), a spray atomiser, and a kneaded eraser for picking out highlights, etc. (see page 9).

You can also get pastels in pencil form. They are not as soft as the sticks but because of this they can be sharpened to a reasonable point, if required (**fig. 9**).

Conté crayon is a similar medium to pastel, but harder in consistency.

Charcoal

An ideal medium when drawing on a large scale, charcoal can be bought either in boxes containing several sticks of willow charcoal or in pencil form (**fig. 10**). Some people may prefer the latter because it does prevent the fingers from getting covered with charcoal. Use the end of the stick for fine lines and the side of a broken piece to cover larger areas. This method of application can also apply to pastel and conté crayon.

Pens and Nibs

It is impossible in the limited space here to show you the complete range of pens available, but in **fig. 11** I have illustrated a selection of the most commonly used ones and these are described below.

A This is a steel crow quill pen, which produces an extremely fine line. The nibs can be bought separately, but there are shops which refuse to sell a nib without a holder. The kind of steel crow quill pen illustrated in **fig. 12** is particularly useful when you are out sketching. The top section comes out, and by reversing it and replacing it in the handle, the nib is covered and protected, enabling you to carry the pen in your pocket or sketch box.

B This is a general drawing pen which consists of a holder and exchangeable nib. When choosing a nib, look at the length from shoulder to point (**fig. 13**): the longer the distance (**a**), the more flexible the nib will be and therefore the more variable the line which can be produced when pressure is applied in drawing. Most suppliers sell sets of varying-sized nibs complete with holder (**fig. 14**), and the bottom section of the pack can be cut away and used as a convenient container when taking the set out sketching.

C This is a Rotring pen. These come in various thicknesses. I have a boxed set containing pens which range from 0.25 to 2.0 – the lines they produce are illustrated in **fig. 15**. These pens are ideal if you require a line to be the same thickness throughout. For this reason they are often used by graphic artists and designers.

D These are felt pens, which come in varying thicknesses from fine to very broad.

E The fountain pen. This is very convenient for outdoor sketching, and has interchangeable nibs.

F The ballpoint pen, useful for sketching outdoors.

Brushes

It may seem peculiar to some people to include brushes in a book on drawing, but brushes *are* used as drawing instruments.

Always buy a good-quality brush, one with some spring in it and which reverts to its original shape after you have used it. If you use a brush with waterproof drawing ink, always wash it out thoroughly immediately afterwards, otherwise it will not last long. It would be sensible to buy a medium-quality brush and keep that solely for using with ink.

The range of brushes is enormous, in size, shape and quality. There are different brushes for different purposes, and they can be pointed, round, chisel- or fan-shaped. Brushes are made of sable hair (the best quality and most expensive), squirrel hair, ox hair or nylon, and **fig. 16** illustrates the ones I find most useful and which I used for all the drawings here.

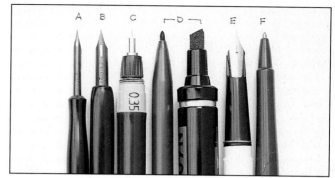

Fig. 11 A selection of pens for drawing

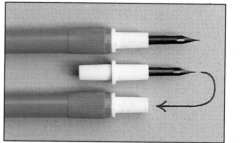

Fig. 12 Steel crow quill pen

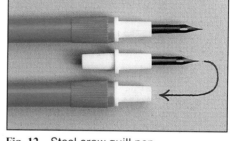

Fig. 13

Fig. 14 Pen set with varying-sized nibs Fig. 15

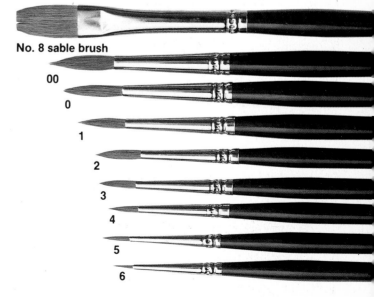

Fig. 16 Round sable brushes and (*top*) brush used for washes

Paper and Board

Paper for pencil drawings can be bought in a roll, as single sheets, or in pad or block form, depending on how or where you intend using it. For example, I suggest you take a ring-bound pad when you go out sketching. This will allow you to flick your completed sketch round to the back of the pad, thus enabling you to start a fresh drawing on a flat surface.

The block-type pad is made up of single sheets of paper bound along three sides with a stiff base board. By placing a knife or other flat instrument into the unsealed edge you can remove the top sheet from the block when you have finished your sketch, in the same way that you would open an envelope with a letter opener. This kind of pad provides a good solid surface on which to work and is fine for indoor work; but it can prove inconvenient when taken out on sketching trips because, having completed a drawing, you have to remove the top sheet in order to work on your next drawing. This leaves the problem of what to do with it. What if you have done half a dozen sketches? Of course you could take a folder to put them in, but that would mean an extra item to carry around and you should always try to keep your equipment to the minimum.

There are also pocket-sized sketch pads and books which are extremely useful for sketching details you think might be useful for future reference. As they fit in a pocket they can be carried at any time without inconvenience.

Ordinary drawing paper can be bought in three different surfaces – Hot Pressed, Cold Pressed, and Rough. Hot Pressed has a smooth surface and is a popular paper. It's ideal for very detailed drawings or when using a sharp nib. Cold Pressed has a good grain on its surface which is satisfying to work on and gives a subtle textured quality to pencil strokes. Rough is a paper that lives up to its name. The surface is very rough and should be avoided if you intend working on a small scale with detailed drawings, although it can be used to good effect with larger drawings, particularly if you are using wash.

There are, of course, thinner, smoother, thicker and rougher papers which you can buy and to cover the whole range would take up most of this book. I recommend you visit a good art materials shop and look at the papers available. Talk to the owner and tell him, or her, what you want the paper for and the medium you intend to work in, and ask for advice.

You may decide to buy a single sheet in order to find out whether you like working on it before committing yourself to a whole pad. On the other hand, you could buy a small pad to start with.

Special sketch pads are made for pastel, chalk, and conté crayon, which contain different coloured tex-

tured sheets of Ingres papers.

If you intend to work in pen and ink and want a clean flowing line, then a very smooth paper or board would be the thing to use. Drawing books containing double-sided board are produced which are ideal for this purpose.

Boards are good to work on because they provide a rigid surface and remain flat when a wash is applied to the surface. They can be bought with the same surfaces as the papers, but are more expensive.

In this book I have indicated which papers or boards I have used for many of the drawings to help give you an indication of the various effects which can be achieved on different surfaces.

KEY to **Fig. 17**

1 Pastels sketchbook and selection of papers
2 Pastels sketchbook
3 Board drawing book
4 Pencil sketchbook
5 Watercolour book
6 Rough drawing board

Fig. 17(*opposite*) A selection of papers and boards

PROPORTION

Correct proportion is vital to good draughtsmanship, but more people make mistakes in this area of drawing than in any other. It makes no difference what you are drawing – the human figure, an animal, plant or building; if you get the basics wrong then whatever you do in respect of colouring or shading, your drawing will always look wrong. My concern here is to teach you to draw realistically, which can only be achieved with an understanding of correct proportion and perspective.

So how do we make sure of getting our basics right? Find out, first of all, how good, or bad, you are in getting the proportions right, by asking a member of your family, or a friend, to pose for you (if you find this embarrassing then stand in front of a mirror, preferably full length, and draw yourself). Do a simple drawing – don't bother with detail or shading. Having completed the drawing, you can check how accurate it is by this simple method. Hold your pencil vertically at arm's length and line up the top of it with the top of your model's head. Then place your thumb on the pencil to line up with the point of the chin (**fig. 18**). This gives you a measure with which to work out how many heads make up the length of the body and, by holding the pencil horizontally, how many heads make up the width. Remember always to keep the pencil at arm's length and your thumb on the same spot on the pencil.

Fig. 18 also illustrates what I find to be the most comfortable way of holding the pencil when taking measurements. This method allows me to see virtually the whole length of the pencil and makes it easier to hold it vertical. If you hold the pencil in your fist, that is, with your fingers wrapped tightly around the pencil and your thumb in position, the pencil leans forward at an angle. This means that you have to force your wrist upwards in order to get the pencil vertical, which you will find uncomfortable when working. Also, only the top of the pencil is visible, which makes it difficult to judge whether it is vertical.

To check your drawing, place the pencil on top of your drawing, lining up the top of the pencil with the top of the head and placing your thumb where you have drawn the point of the chin (there is no need to do this at arm's length, of course). Keeping your thumb at this position, move the pencil down your drawing to find out how many heads make up the length of the body (**fig. 19**). Does this number correspond to the number you worked out when looking at the model? What about the width? You can carry on checking the various parts of the body in this way: for example, the number of heads which make up the length of the arm, from shoulder to hip, from hip to knee, knee to foot, etc.

As well as making sure that each part of your drawing is the right size in relation to the others, you must also check that the angles are right – that the movement of the pose is correct. Hold your pencil vertically in front of you so that it runs the length of the model. Move your eyes down the pencil, checking the position and angle of the body in relation to the vertical line of the pencil. When I was at art school we were encouraged to use a plumb line for this. This can easily be made by tying a weight to the end of a piece of string or cotton. By holding the end of the string and letting the weight hang free, you will get a true vertical line (**fig. 20**). A plumb line is certainly more accurate than a pencil, but the disadvantage of using one is that you have to make sure the weight does not swing, which means you must use both hands to move it from one part of the body to another.

You must also check other angles against a horizontal line (your pencil again). For example, do the

Fig. 18 Establishing a measuring unit

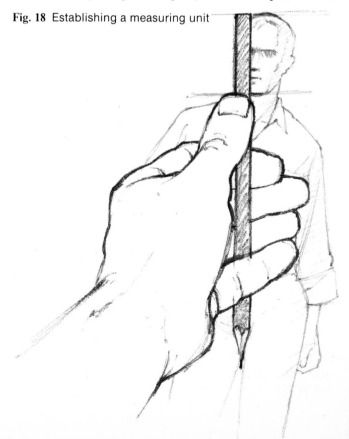

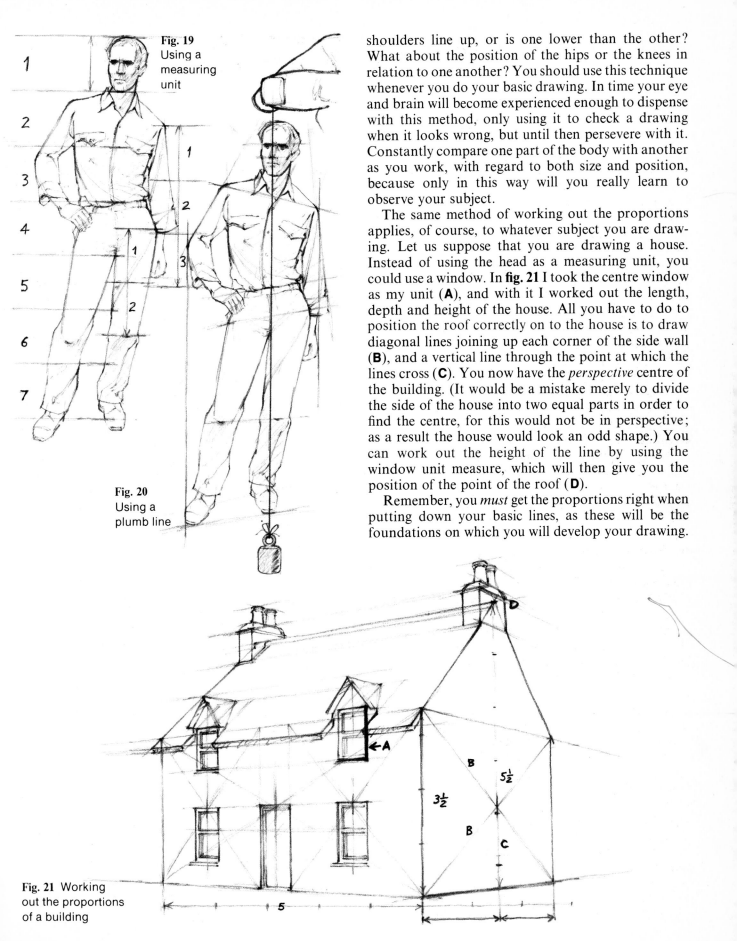

Fig. 19 Using a measuring unit

Fig. 20 Using a plumb line

shoulders line up, or is one lower than the other? What about the position of the hips or the knees in relation to one another? You should use this technique whenever you do your basic drawing. In time your eye and brain will become experienced enough to dispense with this method, only using it to check a drawing when it looks wrong, but until then persevere with it. Constantly compare one part of the body with another as you work, with regard to both size and position, because only in this way will you really learn to observe your subject.

The same method of working out the proportions applies, of course, to whatever subject you are drawing. Let us suppose that you are drawing a house. Instead of using the head as a measuring unit, you could use a window. In **fig. 21** I took the centre window as my unit (**A**), and with it I worked out the length, depth and height of the house. All you have to do to position the roof correctly on to the house is to draw diagonal lines joining up each corner of the side wall (**B**), and a vertical line through the point at which the lines cross (**C**). You now have the *perspective* centre of the building. (It would be a mistake merely to divide the side of the house into two equal parts in order to find the centre, for this would not be in perspective; as a result the house would look an odd shape.) You can work out the height of the line by using the window unit measure, which will then give you the position of the point of the roof (**D**).

Remember, you *must* get the proportions right when putting down your basic lines, as these will be the foundations on which you will develop your drawing.

Fig. 21 Working out the proportions of a building

PERSPECTIVE

Most people have heard the word 'perspective' mentioned at some time in connection with a painting or drawing, but what exactly is perspective? It is the optical illusion which gives us a sense of distance and space, enabling us to differentiate between foreground, middleground and background, thus allowing us to represent depth or three-dimensional objects on a flat surface.

There are two forms of perspective: linear and tonal (known also as 'aerial'). Both methods can be used to convey distance in a drawing. The particular method you choose will depend on the subject you wish to draw. For instance, if you are drawing a street scene or one containing numerous buildings, then linear perspective would be the sensible choice. If, on the other hand, you are drawing a country scene containing trees, hills and mountains, etc., then it would be better to use tonal perspective. Of course you can combine both when necessary. I suppose one could say there is a third form of perspective, in fact. This is known as foreshortening and is described on pages 24 and 25.

There are two main rules governing linear perspective: first, that objects decrease in size in proportion to the distance they are from the person viewing them; and second, that parallel lines will recede to, and meet at, a point on the horizon which is called the vanishing point. **Fig. 22** illustrates the first rule: if you look down a row of houses of identical size, because of the optical illusion they will seem to decrease in size until the one at the far end appears much smaller than the one nearest to you, whereas in reality, of course, they are all the same size. **Fig. 23** illustrates the principle of the vanishing point.

It is also important to understand what is meant by the phrase 'eye level'. It makes no difference where you are, whether you are standing on the roof of a building or lying on the ground, your eye level will always be the level at which your eyes are above the ground. Any receding lines above this will run down to meet your eye level and receding lines below it will run up to the eye level.

Some people find it difficult to establish exactly where their eye level is in relation to the particular scene which they want to draw. If you are working on the coast, your eye level will be the horizon, but most of us live inland and therefore find ourselves drawing in cities, towns, villages or the countryside and, of course, indoors. How then do you establish the eye level? A quick and simple way is to make yourself comfortable in whatever position you intend to work. Look directly in front of you and hold your pencil at arm's length, parallel to the ground, in front of and level with your eyes. Where the pencil cuts across the scene you are viewing will be your eye level (**fig. 24**).

Another method is to rule parallel lines on to a clear sheet of Perspex or glass (make sure the edges of the glass have been filed smooth – we don't want any accidents!) and position the centre line as you would the pencil, directly in front of and level with your eyes (**fig. 25**). The other lines will help you to judge the angles of the buildings or whatever object you are drawing at the time. If you draw the lines at right angles to the edge of the glass, you will be able to line up the edge with the corner of a building or any other vertical line in the scene, which will ensure that the horizontal lines run parallel to the ground.

When using either of these methods, think about what you are doing and study the scene and the position of the eye level carefully. By doing so you will be training your eyes to recognize automatically where the eye level is so that in time, after practising with these aids, you will be able to dispense with them.

If you are a complete beginner or fairly new to the subject of perspective, it's best to avoid difficult subjects at first. Concentrate on easy ones like an isolated cottage or farmhouse, or a simple still life with rectangular objects, until you understand the basic rules of perspective. Start by practising the exercise on pages 18 and 19, which will give you confidence before tackling a more complicated subject.

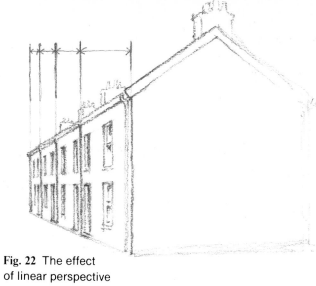

Fig. 22 The effect
of linear perspective

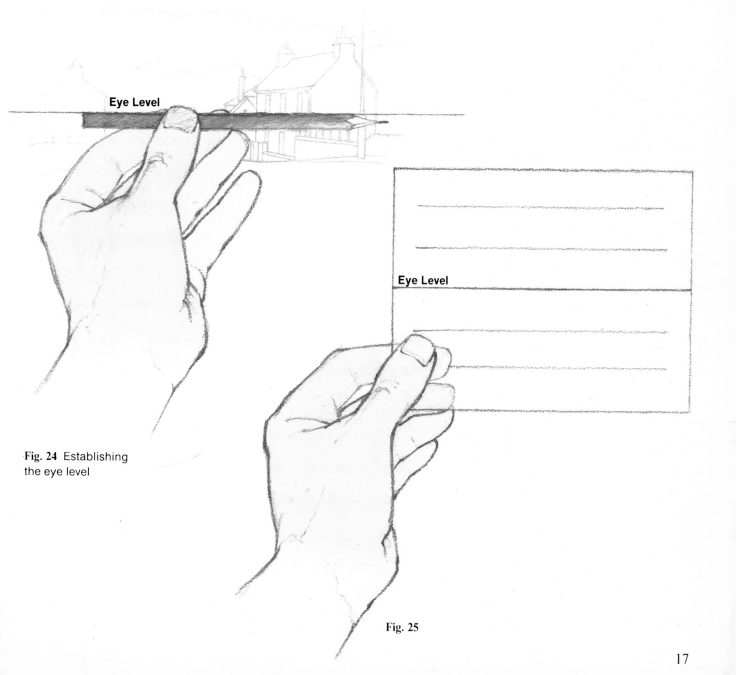

Fig. 23 The principle
of the vanishing point

Vanishing Point

Eye Level

Eye Level

Eye Level

Fig. 24 Establishing
the eye level

Fig. 25

EYE LEVEL AND VANISHING POINTS

To draw a three-dimensional object you need at least two vanishing points. The exercise on these pages illustrates step by step how to construct a rectangular box by using the eye level and two vanishing points.

First draw the eye level and mark in two vanishing points, one to the left of the centre and the other to the right (**fig. 26**).

Then draw two lines radiating from each point. Where they cross will give you four corners, forming the base of the rectangular box (**fig. 27**).

Next draw a vertical line (**A**) from the nearest corner to the height you require the box to be. Then draw lines 1 and 2 connecting the two vanishing points to the top of the vertical line (**fig. 28**).

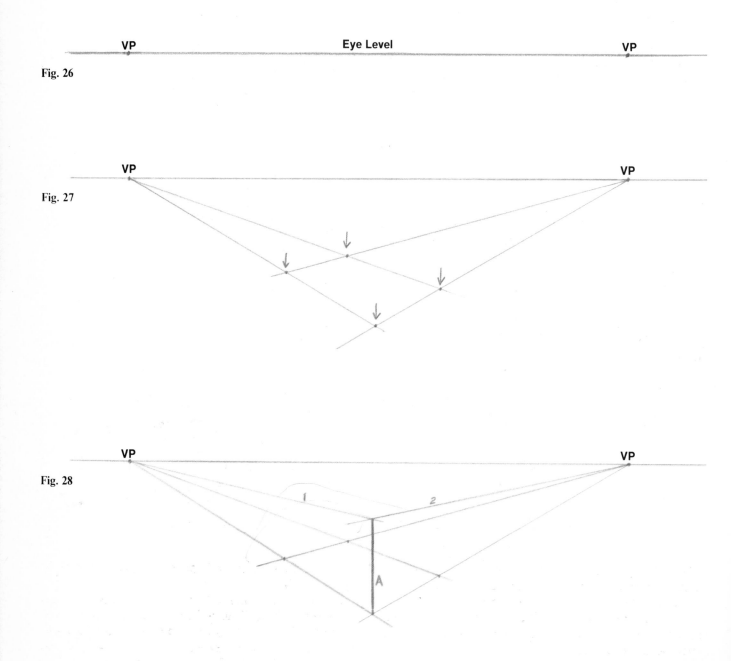

Fig. 26

Fig. 27

Fig. 28

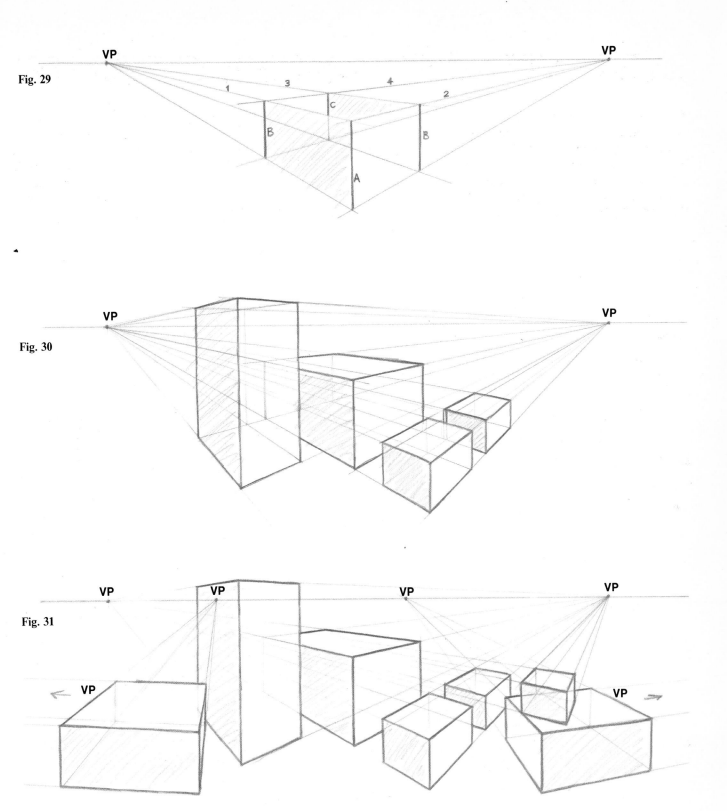

Fig. 29

Fig. 30

Fig. 31

Now draw two vertical lines (**B**) up from the left and right corners to meet lines 1 and 2. Then draw two lines (3 and 4) from each of these points to the vanishing points. Finally, draw a vertical line (**C**) from the far corner of the rectangular base to the point at which lines 3 and 4 cross (**fig. 29**).

You can now proceed to draw any number of rectangular objects of different sizes and shapes just by repeating the process and using the same two vanishing points (**fig. 30**).

You will notice that in **figs. 26-30** there are only two vanishing points. This is because all the boxes are lying parallel to one another. If this were not the case, then more vanishing points would be needed, as illustrated in **fig. 31**. This looks much more complicated, but exactly the same principles apply.

19

LINEAR PERSPECTIVE

In the previous two pages we have looked at the basic rules of perspective using the eye level and vanishing points; but what happens when objects are viewed from unusual angles? You may have already heard the expressions 'bird's-eye-view' and 'worm's-eye-view', referring to high or low viewpoints respectively. In this section I have illustrated these extreme viewing points (**figs. 33 and 34**) so that you can study them and compare them, not just one with the other, but also with a normal viewpoint, known as frontal (**fig. 32**). I have purposely drawn exactly the same scene in each case as this is the most effective way of illustrating the differences between them. The three main elements in each illustration – the human form, rectangular shapes and circular objects – show how a variety of basic shapes are treated. Although I made the three drawings from different levels I made sure that I viewed them from the same direction.

Frontal (normal) view

Fig. 32 shows the angle at which we observe a scene when standing at ground level. Anything taller than the distance from the ground to your eyes will extend above your eye level; conversely, any object shorter than the distance from the ground level to your eyes will remain below your eye level. Of course there can be exceptions to that rule: the smaller objects could be on top of a hill or some other raised area, which would put them above your eye level.

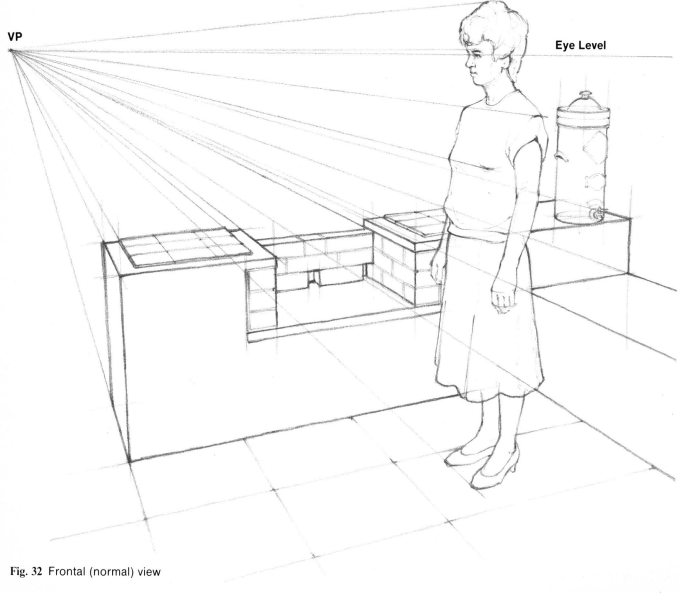

Fig. 32 Frontal (normal) view

Bird's-eye-view

Fig. 33 shows the scene from above (I was, in fact, standing on the top of a step-ladder!) – a bird's-eye-view. You will notice that all the objects are well below the eye level, and therefore all the receding lines have to travel up to the vanishing point. You will also notice that there are now three vanishing points. This is because we are looking down the length of the figure and other objects, which causes lines to recede from us and into the ground, producing a foreshortening effect (see pages 24 and 25).

Study the figure carefully. Look at the distances from the top of the head to the waist, from the waist to the hemline of the skirt, and from there to the feet. Compare these with the distances on the figure in the frontal view drawing (**fig. 32**).

Fig. 33 Bird's-eye-view

Worm's-eye-view

We now go to the other extreme, known as a worm's-eye-view (**fig. 34**). In this instance the eye level is close to the ground. I was particularly uncomfortable producing this drawing because I had to lie flat on a paved patio and force my head back in order to view the scene! After a while my shoulder and neck muscles began to ache, not to mention those muscles I never knew I had until that moment!

You can see that once more we have an obvious third vanishing point, this time above the eye level because we are looking up the length of the subjects. This is in complete contrast to the previous drawing where I was looking down at the same objects, which, you will remember, produced a vanishing point below eye level.

Look at the distance between the various points of the body as you did for **fig. 33** and compare these with both of the other views. Most lines now recede down to the eye level because each subject extends above that line. Notice the foreshortening effect this viewpoint has on the paving stones – the area occupied by each stone gets smaller the further away it is, because you are looking along the stones. Compare this with those in the bird's-eye-view, where this receding effect becomes less obvious because you are looking down at them.

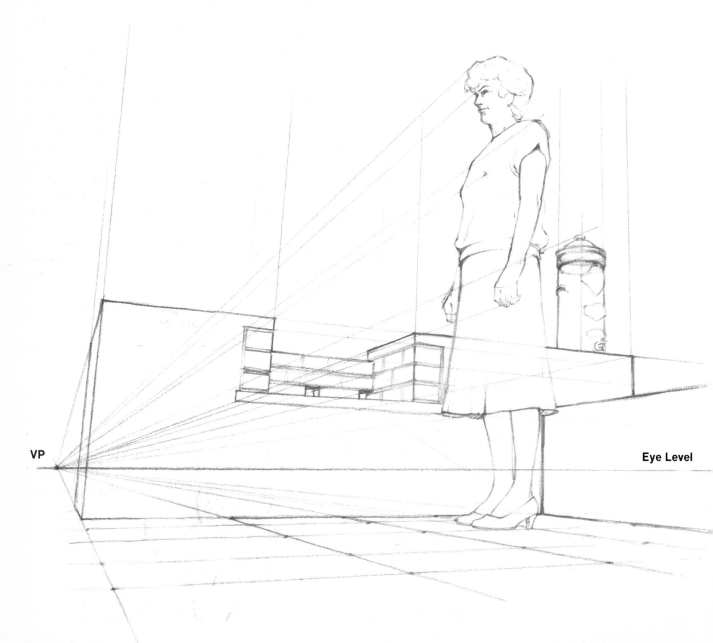

VP

Eye Level

Fig. 34 Worm's-eye-view

TONAL PERSPECTIVE

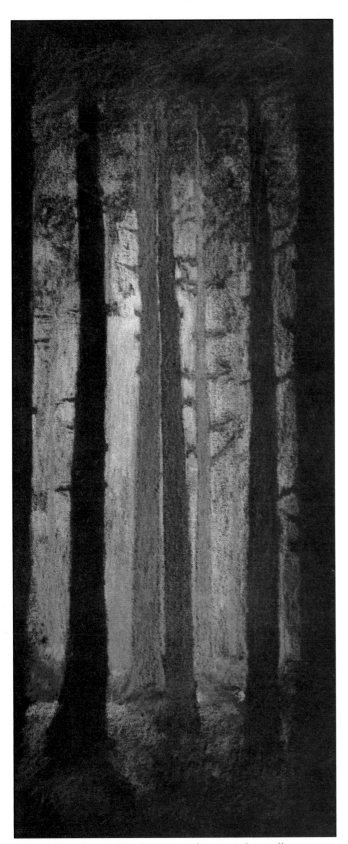

This is the illusory effect whereby distant objects appear less distinct in outline and colour than those nearer the observer. It is caused by atmosphere which blurs and softens colours and reduces the differences between light and shaded areas.

You will come across situations where it is not possible to use linear perspective to indicate depth and distance – for example, when drawing a landscape – and in these cases the only course open to you will be to use tonal perspective. This means you must vary the strength of the tones in your drawing. It is best to start with the darker, sharper tones in the foreground and work back through the middleground to the lighter, softer tones of the background.

When going out to practise this technique, it's important to choose your day carefully. For instance, one of those warm hazy summer days would be perfect for doing landscape as the haze would cut out most of the details and subdue the colours, thereby showing up to advantage the various tones contained in the scene. Misty autumnal days create a similar effect.

I used pastel pencils on black paper to produce the drawing of the woods (**fig. 35**). If you decide to try pastels, chalk, charcoal or very soft pencil, remember to take something with you with which to fix your drawings. A putty rubber can also be very useful to lighten tones you feel you have made too strong.

You can of course produce a tonal effect using line only, as illustrated in **fig. 36**. You will see that I have varied the strength of line, making those in the foreground strong and dark and gradually lightening them as they recede into the distance.

Fig. 35 Drawing on black paper using pastel pencils

Fig. 36 Producing a tonal effect with line only

FORESHORTENING

Foreshortening is another form of linear perspective by which the length of an object from front to back is visually severely reduced. It is therefore important to use the measuring method described on page 14 while working out distances, positions and proportions of the various features and sections of your subject. You will be surprised at how small an area each part occupies, and how much detail you will need to incorporate into that area.

Be observant when looking through a magazine or newspaper and look carefully at any photograph that contains a foreshortened view of an object or person. Do the same when out walking. This way you will mentally store up knowledge which will help you to understand the rules which govern the effect of fore-shortening. If you have time, make a sketch of any foreshortened object you come across. It need not be detailed or highly finished but just enough to remind you of the relationship between the various elements contained in the length of the subject when viewed at an acute angle.

For a beginner, foreshortened views can be difficult to draw. Many amateur artists have a tendency when drawing the human figure to draw the features as they normally see them, or know them to be, rather than accurately recording the foreshortened view. If you do not yet feel confident enough to attempt this aspect of drawing, then leave it until you have gained more

experience in the other fields covered in this book. You can then, having practised and gained that experience – and with it more confidence – come back to this section. It can be very discouraging and off-putting to attempt something difficult when you have no confidence of success. Remember, you want to enjoy your art! Having said that, I must admit that there is nothing quite like the feeling of exhilaration and pride in accomplishing an acceptable result when attempting something which you thought was beyond your

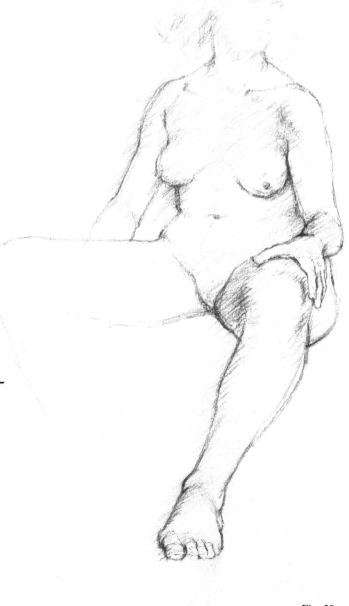

Fig. 37

Fig. 38

Fig. 39

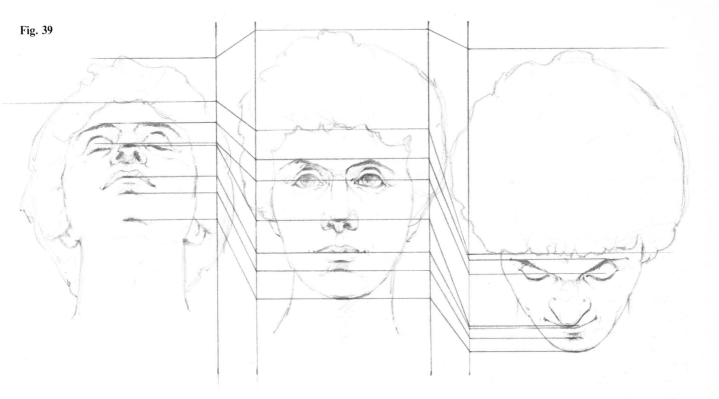

capability. The choice is yours; but if you do try these difficult viewpoints and are disappointed with the results, don't let that put you off. It would be unrealistic to expect immediate success; it takes practice. Carry on with the other exercises in this book, then come back to this one and try again.

On the reclining figure in **fig. 37** I have drawn horizontal lines across the critical points which need to be carefully established in order to produce a convincing drawing of this nature. Any one of the sections can be used as a measuring unit. I like starting such a drawing with the head so in this case I chose the distance from the tip of the nose to the chest (**A**).

The seated figure (**fig. 38**) is deceptive. Overall it appears to be a normal view, until you look at the leg on the right – the thigh is drastically foreshortened. You should watch out for this kind of thing whenever you set up the pose of a model. At a life class you will often see the students moving around the model looking for a suitable spot from which to draw. They are looking out for a number of things, such as the angle of light (which affects the modelling of the contours); an interesting view of the pose itself; and a means of avoiding awkward foreshortened views!

In **fig. 39** I have used the head to illustrate how foreshortening affects the distance between the various features and, of equal importance, the shape of them. The illustration consists of three views: one normal, the other two at an acute angle, with the head tilted back and forward. Study them carefully. Notice how the space between the tip of the nose and the mouth becomes virtually non-existent in the head on the right.

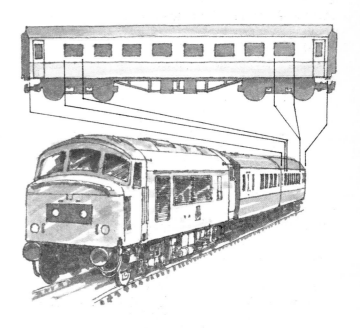

Fig. 40

The train (**fig. 40**) is a classic example of foreshortening – we have all witnessed this at the railway station. The diagram illustrates how drastic the effect can be. The length of the carriage viewed sideways on is greatly reduced in the foreshortened view, but the same details need to be shown, with individual elements such as the windows decreasing in height and width as they recede into the background.

CIRCLES AND ELLIPSES

Circular objects pose a problem to many artists because when viewed at an angle – or, in other words, in perspective – they take on an elliptical shape. This is illustrated in **fig. 41**. You can make a diagram like this yourself by drawing a circle on to a piece of stiff card or cartridge paper. It's preferable to draw two circles within a square as I have done so that you can see how the distance between the two circles changes as you tilt the card away from you. For example, notice how the distance between the circles at points **A** and **B** has become narrower than that at **C**. This is caused by the fact that you are viewing the circles in perspective; you are looking across the lines at **A** and **B**, whereas at **C** you are looking along, or between, them, which means the gap at that point remains wide. In order to provide the correct information the diagram must be accurate, therefore you must use a compass to draw the circles and a ruler and set-square to draw the square.

Drawing a square to encase the circles will also enable you to see that the half of the ellipse which is furthest away from you occupies less space than the half nearest to you (**fig. 41, D** and **E**). With the help of your card diagram you will be able to study what happens to the circles at any angle.

In **fig. 42** I have drawn one of the storage jars which my wife uses in the kitchen, in order to illustrate how the knowledge gained from the diagram can help when drawing circular objects of this kind. For instance, the principles of drawing the lip of the jar (**F**, **G** and **H**) are exactly as shown in **fig. 41**. Never draw pointed ends on an ellipse – always round them off (**fig. 43**); and never finish a continuing curve abruptly as in **fig. 44** – again, round it off as illustrated in **fig. 42**.

When drawing objects like this you can make the task easier by putting in a centre line. You can then roughly draw the ellipse and check that the right and left edges are an equal distance from the centre (**fig. 45**). You could even 'box in' the ellipse. In fact, draw in any lines you feel might help you to produce an accurate elliptical shape.

Fig. 41 The effect of perspective on circles

Fig. 42

Fig. 43

Fig. 44

Fig. 45

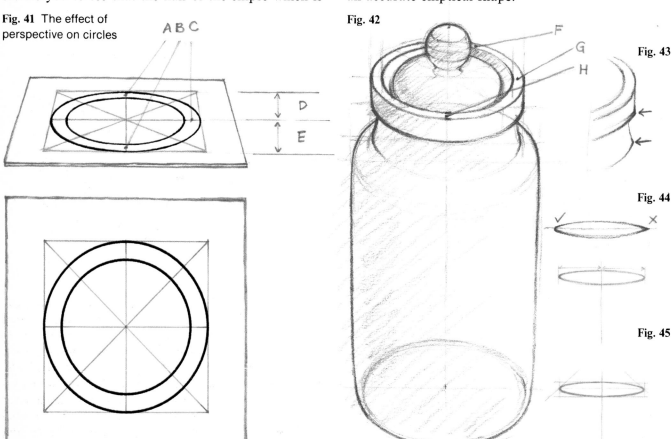

Fig. 46

Fig. 47

REFLECTIONS

I do not want to be too technical by giving you a scientific explanation of the laws which govern the process of reflection, so let me simplify matters by saying that reflection is the result of light waves being thrown off a surface and travelling back to the viewer. In other words, when you stand in front of a large mirror your light waves bounce off the mirror surface and back to your eyes, giving you an image of yourself. Because light waves have travelled to the mirror and back again, your image will appear at exactly twice the distance that you are actually standing from the mirror (**fig. 46**). When drawing a reflection it must therefore be shown in perspective (**fig. 47**).

Most of us at some time or other have witnessed the reflecting qualities of water and if so, you will have noticed that reflections appear darker in tone and colour than the original object (**fig. 48**). This is because some of the light is refracted. That means the light is broken up and sent off at different angles, and therefore less of the light returns to the viewer. This has the effect of causing the colours to appear darker.

Fig. 48

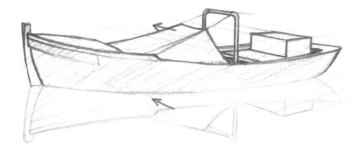

Fig. 49

Another point you should have noticed is that the reflected image gives you a reverse view of the original object. For example, if you look at the boat in **fig. 49** you will see that it is viewed from above – but just look at the reflection. To make things easier, turn the book upside down. The view of the reflected image is reversed; you now have a worm's-eye-view. Because of the fact that it is a mirror image, all lines run parallel to those of the original object, so when they recede, therefore, they meet at the same vanishing point.

SKETCHING

When the word sketching is mentioned, many people immediately think of a quick scribbled drawing. This of course is accurate, in *some* cases. But a sketch can also be a meticulous, detailed study drawing.

Sketching can be broken down into two distinct categories. First, drawing for pleasure, which will also have the effect of improving your draughtsmanship because of the practice gained in the process. Second, drawing to obtain information, either to keep as reference for possible future use or to use specifically on some work you are already involved in, or intend doing. This category can further be broken down into practising drawing things which you find difficult, such as hands (**fig. 51**).

The second kind of sketching is a means of gathering specific information to increase your knowledge of nature, architecture, transport or people, etc. To give you an example: an artist interested in figure drawing would use his sketchbook to draw details of the head and features; to make study drawings of the effect that muscles have on the surface shape of the body (**figs. 50 and 52**); and to record what happens to the folds of a garment when a person adopts a certain pose (**fig. 53**). This type of drawing can be done at home.

When sketching for pleasure, you can go out with no particular subject in mind and just spend a couple of hours or so drawing what you find pleasing and interesting. It could be a landscape, a seascape, a woodland scene, an old church, or whatever interests you at the time (**fig. 54**).

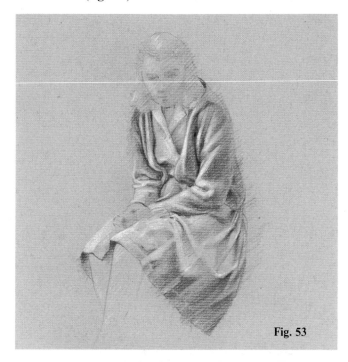

Fig. 53

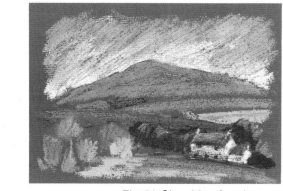

Fig. 54 Sketching for pleasure

Fig. 50

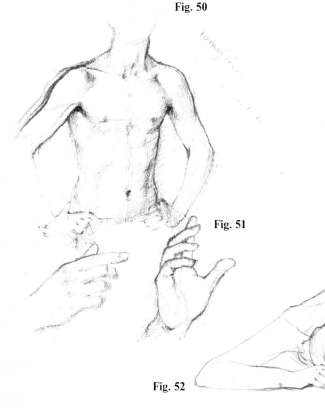

Fig. 51

Fig. 52

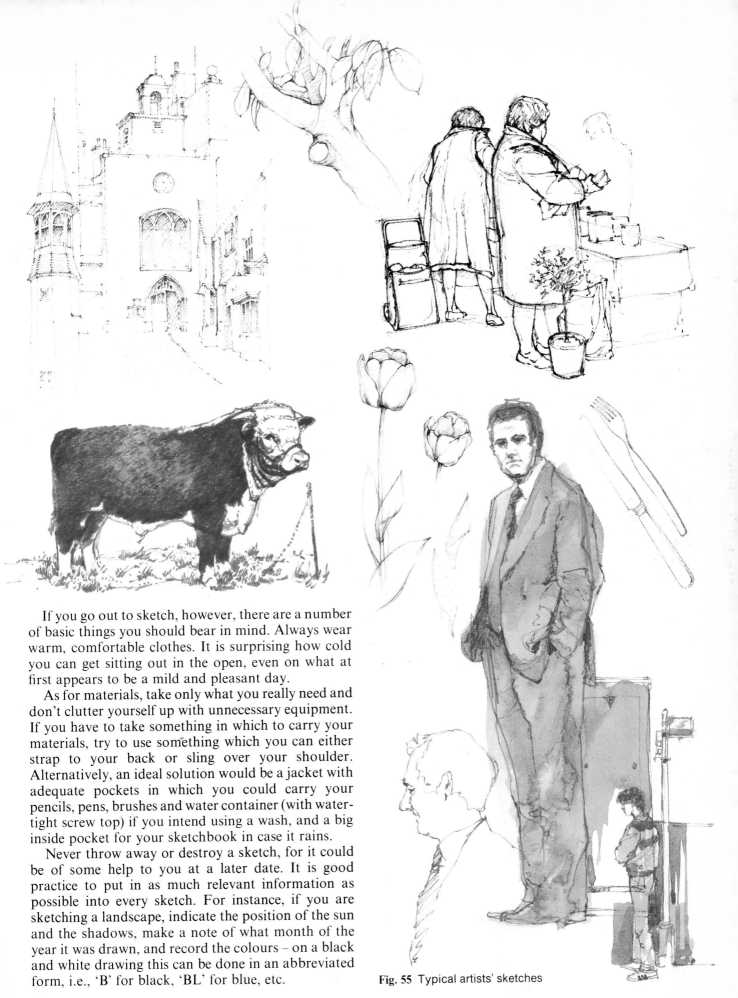

If you go out to sketch, however, there are a number of basic things you should bear in mind. Always wear warm, comfortable clothes. It is surprising how cold you can get sitting out in the open, even on what at first appears to be a mild and pleasant day.

As for materials, take only what you really need and don't clutter yourself up with unnecessary equipment. If you have to take something in which to carry your materials, try to use something which you can either strap to your back or sling over your shoulder. Alternatively, an ideal solution would be a jacket with adequate pockets in which you could carry your pencils, pens, brushes and water container (with water-tight screw top) if you intend using a wash, and a big inside pocket for your sketchbook in case it rains.

Never throw away or destroy a sketch, for it could be of some help to you at a later date. It is good practice to put in as much relevant information as possible into every sketch. For instance, if you are sketching a landscape, indicate the position of the sun and the shadows, make a note of what month of the year it was drawn, and record the colours – on a black and white drawing this can be done in an abbreviated form, i.e., 'B' for black, 'BL' for blue, etc.

Fig. 55 Typical artists' sketches

LIGHT AND SHADE

In spite of the fact that we are continually surrounded by light and shade in our daily lives, when it comes to representing them on paper, it is the process that most terrifies and confuses the beginner.

When I first started at my local art school in Wales, I was quite happy to have a go at producing line drawings. When I was told that I would have to use shading in order to produce visually three-dimensional drawings, I felt the unease rise within me. My first attempts were so delicate that the pencil marks were virtually invisible! As I practised I became more interested in this new technique, as I then regarded it. In fact, I became so absorbed in the process that I went to the other extreme. In my finished figure drawings it looked as if the skin of the model was made of black velvet. I will never forget the remark made by one of the tutors. He came up and stood behind my right shoulder, paused, then leaned over and whispered, 'She looks as if she has just come up from a coal mine.' From that moment I began to think of light as well as shade.

By studying the behaviour of light I discovered that the area most hidden from the light source is not necessarily the darkest; that light is reflected; and that this reflection produces shadows of varying degrees of intensity. You will notice that in the drawing of a ball (**fig. 56**) the light is reflected by the white surface. The drawing also illustrates the effectiveness of shading, showing how it can turn a two-dimensional circle into a three-dimensional sphere.

Photographers sometimes accentuate reflected light by the use of light-coloured screens or curtains placed near the person or object they are photographing, in order to soften the shaded areas. This technique pro-

duces a more interesting and subtle quality in the modelling. A strong light coming from one direction only can produce shadows so strong that they obliterate the modelling contained in the shaded side, producing extreme contrast between very dark and very light areas. Of course, you can use this to your advantage if you want to produce a dramatic effect (as I did in **fig. 57**, an illustration for a publisher), but for the purposes of learning to draw I should avoid these extremes.

I'd advise you not to use strongly coloured or patterned objects in the early stages as they will only

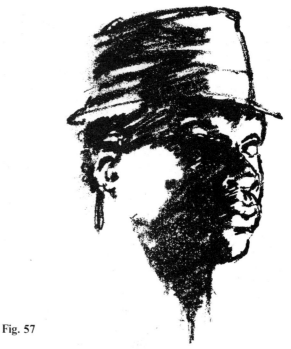

Fig. 57

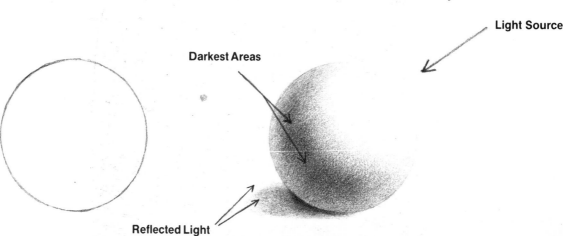

Light Source

Darkest Areas

Reflected Light

Fig. 56

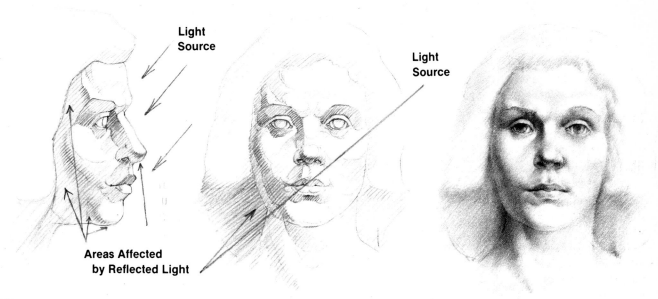

Light
Source

Light
Source

Areas Affected
by Reflected Light

Fig. 58

confuse you. Likewise, avoid using glass objects at first when setting up a still life group. Light goes through glass and its surface will therefore contain reflections of the other objects surrounding it, and you will need to have gained some experience before trying to draw these accurately.

A good way of studying the behaviour of light is to break down your subject into more basic forms as I have done in **fig. 58**. Make a note of where the darkest areas are and which areas are affected by the reflected light. This analytic approach to your drawing will also help you to learn a little bit about the anatomy of the body. I used a B pencil on fine-grain cartridge paper for this drawing.

I consider myself very fortunate to have gone through an art school training. Not only were we supplied with live models from which to study, but we were also set exercises drawing from plaster casts of sculptures by artists such as Michelangelo. As well as being beneficial in the study of anatomy, because the casts were devoid of colour they were also excellent

when it came to studying the effect of light on an uneven surface.

It is of course unrealistic to expect anyone to have such facilities at home, but a surprising amount of information can be gleaned from quite simple objects. Take the earthenware plant pot as an example (**fig. 59**). Because of its simple shape it reveals the behaviour of light more clearly. Notice, for instance, the inside rim (**A**). The surface faces the light almost directly and is therefore lighter than any other within the pot; but where the rim is in the shadow of the left-hand edge of the pot, it becomes the darkest area, because it does not catch the reflected light from the inside right-hand side of the pot.

Notice also the underside of the outside rim. It is affected by the light being reflected off the surface on which the pot is standing, which has the effect of making that part of the underside of the rim lighter than the adjoining surfaces. Apart from a pencil, I find pastels ideal for this type of study; I used pastel pencils on Ingres paper to draw this pot.

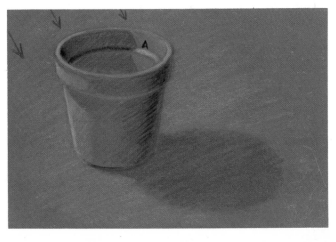

Fig. 59

TECHNIQUES

Charcoal

As you go through this section of the book you will notice that each medium has a quality of its own. This applies particularly to charcoal. It's unfortunate that many regard charcoal as a messy medium, suitable only for producing heavy black work on a large scale or for drawing on canvas as a basic guide to painting. It is true that it can be messy and heavy in appearance, but this can be turned to an advantage to produce a forceful and exciting piece of work.

I find charcoal an expressive and sensitive medium, one which can be used effectively to produce a particular mood, such as the overcast sky with a half-hidden sun in the landscape below (**fig. 60**). This was drawn on a small scale, 106×260mm ($4 \times 10\frac{1}{4}$in), by applying charcoal and then rubbing it with a finger. The hazy sun was picked out with a putty rubber, as were various sections of the foreground.

The drawing of the man (**fig. 61**) was done on rough cartridge paper, using the side of a broken-off piece of charcoal to draw the hair, shadows and coat. The feature details were drawn in by using the end of the stick. No rubbing at all was done, and a putty rubber was used only to break down the background near the bottom right-hand side of the drawing. I found charcoal a good medium to capture the expressive quality portrayed in the face.

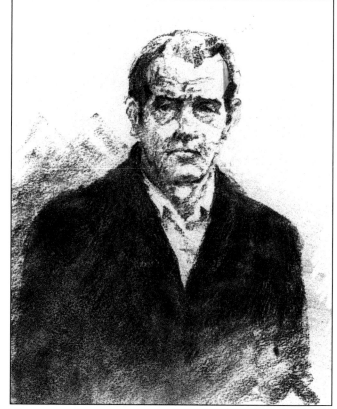

Fig. 61

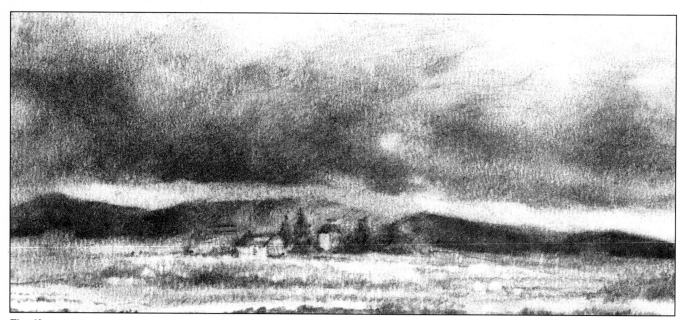

Fig. 60

Fig. 62

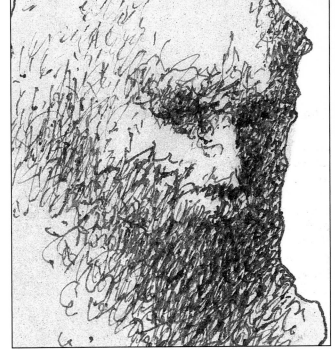

Detail of **fig. 62**

Pen

Because of the permanency of ink (it cannot be erased), beginners are often frightened to draw with it. They tend to draw first in pencil and when satisfied with that they then 'trace' over the pencil lines with ink. The result is a stiff, uninteresting drawing devoid of any subtlety of line or freedom of movement. If you find that you have placed a line incorrectly, use it as a guideline in correcting your drawing. Pen and ink is a good medium with which to sharpen up your powers of observation.

There is a variety of techniques available to you when you use pen and ink. You can adopt the linear style or use the cross-hatching method of shading, in which one series of lines crosses another. An alternative method is the scribbling technique, which I used to produce a rough illustration for a book jacket (**fig. 62**). You can also use the traditional (mapping) pen and wash, which complement each other very well (**fig. 63**).

When deciding which method to use you should also carefully consider which nib and paper or board you will need. For instance, it would be unwise to choose a very rough cartridge and a sharp-pointed dip-in nib for the scribbling technique, as the nib would have a tendency to catch on the rough surface, especially on an upward stroke, resulting in a spattering of ink across the surface of the paper. A ballpoint pen would be more appropriate, or a fountain pen; i.e., a pen with a smooth or rounded end to the nib so that it can flow smoothly over the rough surface.

Fig. 63

Coloured Pencils

Compared with most other media, the wax-based coloured pencil is a relatively modern medium. It was first produced for use by children but soon became recognized by the manufacturers as a potential medium for the serious artist. Over the years the quality of these coloured pencils has been improved and they are now accepted as a welcome additional medium by both students and professional artists.

A technique which is proving very popular with a number of artists, particularly illustrators, is to combine coloured pencils with watercolour paints. **Fig. 64** was produced by this method. First a watercolour wash was applied (**A**), then after strengthening this slightly (**B**) the drawing was completed with coloured pencils (**C**). There are also coloured pencils on the market which are water-soluble. They are made specifically to use with water, each pencil stroke being washed over with a paint brush. I have yet to try this method, but for the moment I prefer to use the pencils 'dry'.

Coloured pencils are very flexible and subtle changes in the line can be achieved by varying the pressure when drawing. For example, gentle pressure produces a light, soft effect, whereas increased pressure results in a darker, more intense colour. The pencils can be used on most types of paper and board, but I prefer a hard surface so that I can apply pressure without leaving a groove in the paper. Strokes can be applied in a cross-hatch pattern, laying one series of strokes diagonally on top of another (**fig. 65**), or you can gently 'rub' the pencil over the surface you wish to cover, increasing the pressure for the darker areas (**fig. 66**). Another method is to lay down various coloured diagonal strokes side by side leaving the eye to do the colour mixing (**fig. 67**). I used a combination of the 'diagonal side by side' technique and the rubbing method in drawing the foxglove on page 55.

There is no right or wrong way of using a medium. The method chosen depends on the effect you wish to achieve, but with coloured pencils I recommend working from light to dark. Start by laying down the lightest colours, gradually building up the drawing through the various tones, and finishing with the darkest colours. This is advisable because, in essence, coloured pencils are transparent and it is therefore impossible to turn a dark area into a light one by applying a light colour over the top.

Fig. 65

Fig. 66

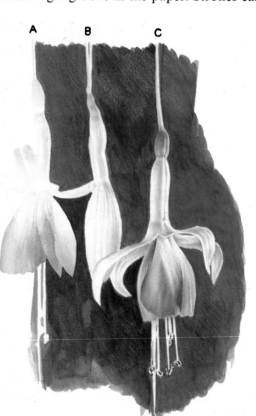

A B C

Fig. 64

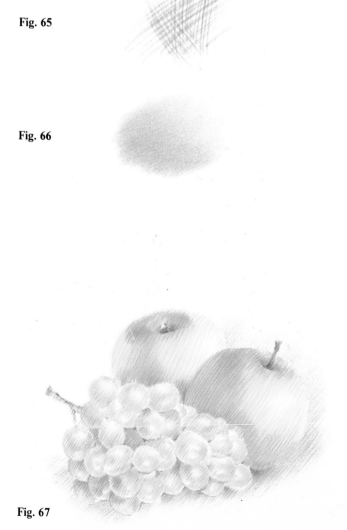

Fig. 67

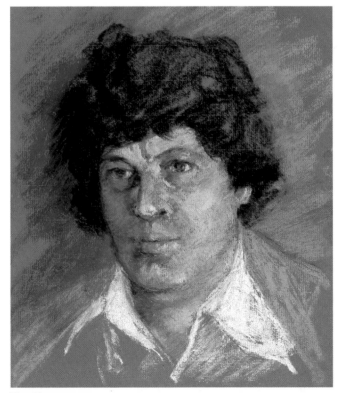

Fig. 68

Pastels

Artists use pastels in various ways. There are those who like to blend the colours, mixing two or more colours in varying quantities to produce the exact hue desired. The purists, however, prefer to use pastels as they would pencils, so they draw individual strokes in a sort of cross-hatch pattern, thereby allowing the colour or colours underneath to show through, and leave the eye to do the mixing. Another method is to soften the effect by rubbing, either with a finger, a French stick, cotton wool or soft brush.

Fig. 68 was drawn on white paper and the pastels were rubbed with a finger. The light areas were then picked out with a putty rubber. **Fig. 69** was drawn on dark brown Ingres paper; because of their opaque quality, pastels work extremely well on coloured paper. The method used here was not to rub, but to work one colour into the other, though taking care not to overdo it. As you can see in the detail, in certain areas the paper was allowed to show through.

The portrait on the cover was also done in pastels, but in a very different way. Again it was drawn on coloured Ingres paper, but this time only two colours were used: red for the darker areas and white for the highlights. These were softened and blended into the paper by rubbing with a fine-point French stick, or smudger as it is commonly called. The colour of the paper itself then made up the middle tone, connecting the dark areas with the highlights.

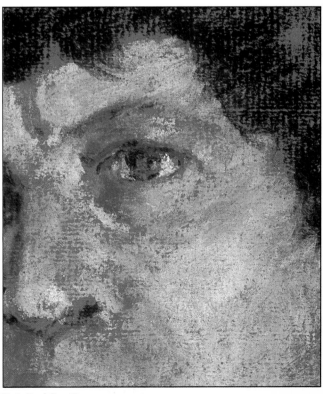

Fig. 69

Detail of **fig. 69**

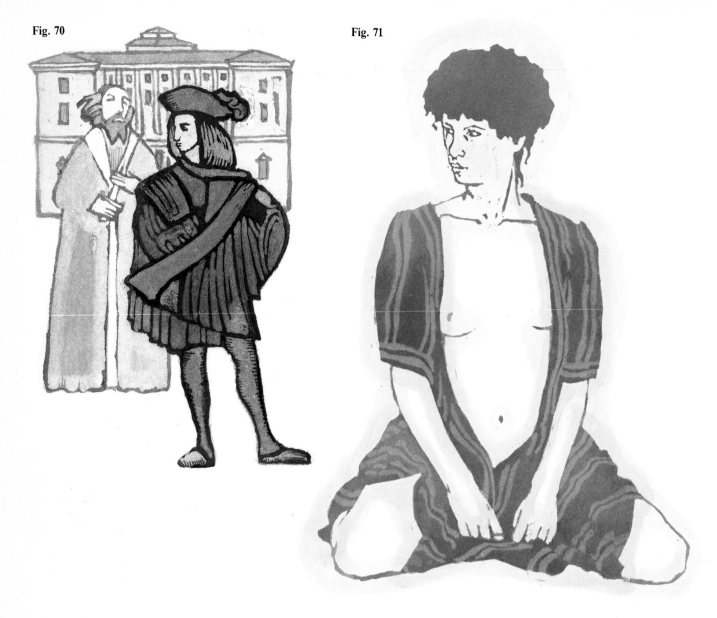

Fig. 70 Fig. 71

Masking Fluid

This is a liquid used for masking areas of work to be protected when applying washes of ink, paint or any other water-based colour. You need to shake it well before using, for it is tinted yellow and if the bottle is left standing for any length of time the yellow colouring tends to separate and sink to the bottom. When dry, the liquid has a thin rubber-like consistency, thus resisting any wash that is applied.

This technique can be used to good effect when a drawing or illustration demands a linocut or woodcut appearance such as that in **fig. 70**, which is an illustration rough I did for a book jacket. Although only a rough, the medium helps considerably to indicate what the finished illustration would look like.

The woman in **fig. 71** was first drawn in pencil, then all the areas which were to remain white were painted over with masking fluid. This also included the light orange striped area on the garment. When dry, brown ink was painted over the uncovered areas. After the ink had dried, a soft eraser was used to remove the masking fluid. This left a drawing in brown ink, except for the stripes, which were white, with the garment in solid brown like the hair. Masking fluid was once more applied, this time avoiding the area of the garment, but covering everything else, such as the arms, legs, body and background. When dry, the whole garment was then painted over with orange ink. As soon as this was dry, the masking fluid was again removed, leaving the finished drawing you can see.

Various media can be used as a wash. I have already mentioned ink, but you can also use watercolour and watered-down designers' gouache. If using the latter, don't apply the paint thickly otherwise you will find it difficult, if not impossible, to remove when dry. Try overprinting three, four or more colours by re-applying the masking fluid.

Fig. 72 First stage

Fig. 73 Finished stage

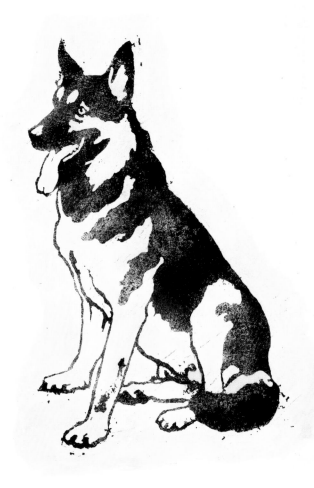

Stipple

This is a technique which will be familiar to the many people who used this method in art lessons while attending primary school. I distinctly remember cutting out various flower-shaped stencils, mixing up colours using powder paint, and using a stipple brush to dab them into the cut-out areas. Some artists still use the stencil method when stippling, but I prefer to use masking fluid. That way I can get a more subtle quality to the line and can also produce fine lines when necessary.

To produce the German shepherd dog above first draw it in pencil. Then paint all the areas which you want to remain white with the masking fluid (**fig. 72**). When this is dry stipple the whole area with watered-down black designers' gouache; you can vary the quality of the stipple by adding more or less water. Do not put your paint on thickly otherwise you will have

difficulty removing it. It is advisable to have a spare sheet of paper handy on which to test the quality of the stipple and get rid of the excess paint before applying it to the actual drawing. When the paint is dry rub over the areas covered by the masking fluid and the gouache to remove the surplus paint (**fig. 73**).

Use a rough cartridge paper or watercolour board. Do not use a soft-surfaced paper otherwise you will find that not only the fluid and the paint but also the surface of the paper will come off when you rub. You may be able to peel off the masking fluid, but failing this, rub it with your finger or soft eraser. Do this as soon as the work is completed.

I have kept this exercise simple in order to explain the basic technique, but there is no reason why you should not extend the process by using different colours, stippling one over the other, for instance. Why not apply a transparent wash over parts or the whole of the drawing when it's dry? Experiment!

Candle and Wash

The use of a candle as a medium may seem unbelievable to some people, but it can be used successfully to obtain certain effects. Take, for example, the drawing of the cat in **fig. 74**. I particularly wanted to produce the mottled texture of the fur, and the candle technique is ideal for this.

I started by making a drawing of the cat in pencil on a rough watercolour cartridge paper. I rubbed a candle over the areas I wanted to remain light, then applied a mixture of black and reddish-brown watercolour in varying degrees of density, depending on the colouring and modelling of the cat, over the whole drawing. Because of the rough texture of the paper, the wax of the candle was unable to cover completely those areas on which it was applied, so when the wash was applied over it, it produced the mottled effect which I wanted. Where there was no wax on the drawing the wash immediately soaked into the paper. I controlled this by applying a dark or light wash as required. Details such as the eyes and whiskers were then drawn with a brush to complete the work.

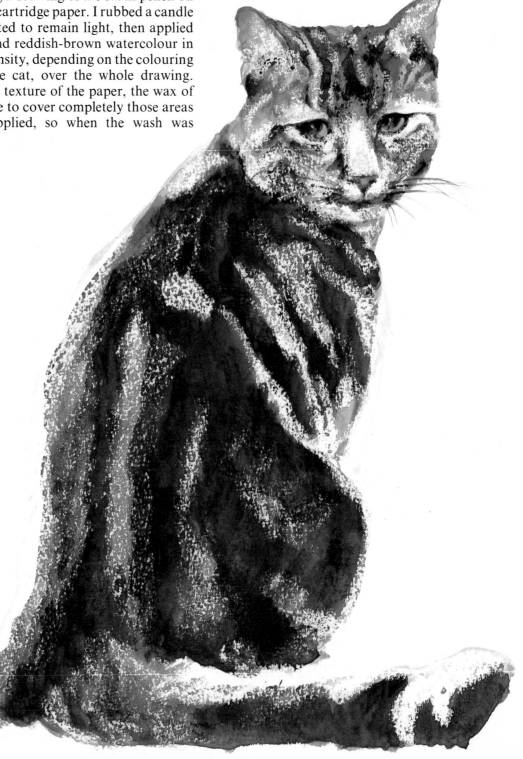

Fig. 74

38

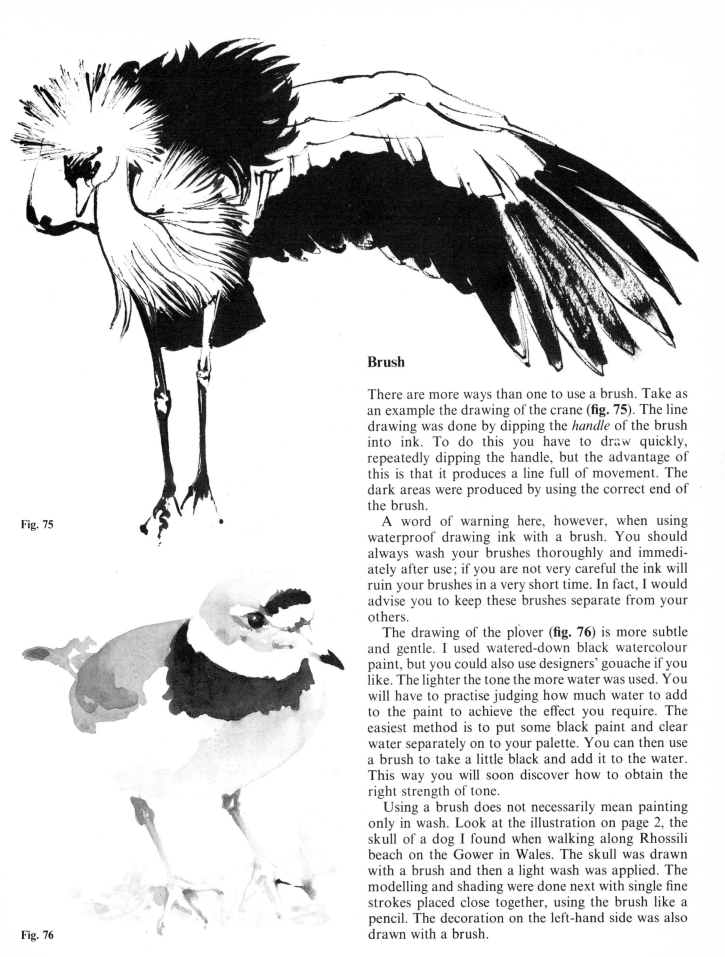

Fig. 75

Fig. 76

Brush

There are more ways than one to use a brush. Take as an example the drawing of the crane (**fig. 75**). The line drawing was done by dipping the *handle* of the brush into ink. To do this you have to draw quickly, repeatedly dipping the handle, but the advantage of this is that it produces a line full of movement. The dark areas were produced by using the correct end of the brush.

A word of warning here, however, when using waterproof drawing ink with a brush. You should always wash your brushes thoroughly and immediately after use; if you are not very careful the ink will ruin your brushes in a very short time. In fact, I would advise you to keep these brushes separate from your others.

The drawing of the plover (**fig. 76**) is more subtle and gentle. I used watered-down black watercolour paint, but you could also use designers' gouache if you like. The lighter the tone the more water was used. You will have to practise judging how much water to add to the paint to achieve the effect you require. The easiest method is to put some black paint and clear water separately on to your palette. You can then use a brush to take a little black and add it to the water. This way you will soon discover how to obtain the right strength of tone.

Using a brush does not necessarily mean painting only in wash. Look at the illustration on page 2, the skull of a dog I found when walking along Rhossili beach on the Gower in Wales. The skull was drawn with a brush and then a light wash was applied. The modelling and shading were done next with single fine strokes placed close together, using the brush like a pencil. The decoration on the left-hand side was also drawn with a brush.

Felt Pen

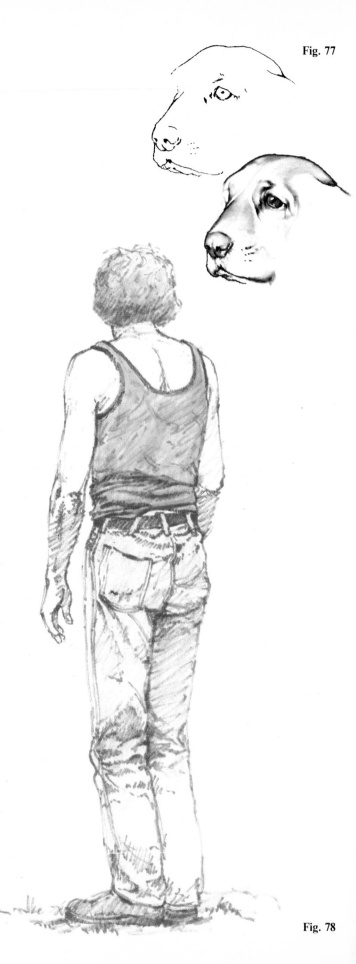

Fig. 77

I should imagine that there are very few people who have not used a felt pen at some time or other. These pens are relatively inexpensive and easily obtainable at newsagents, stationers, toy shops, stores and, of course, art shops. They range in quality from the very cheap ones to the expensive types used by professional designers and illustrators, and they are produced in a variety of shapes and thicknesses.

Because the range of pens is so vast I have confined myself to showing you two techniques which are not normally seen. In fact, I discovered the technique used to produce **fig. 77** when I accidentally ruined a felt pen drawing I was doing by placing a wet hand on it! For this technique you need a non-waterproof felt pen. Some felt pens are waterproof, so if you intend buying a felt pen to use in this way, make sure that you choose one that is not. An easy way of testing this is to make a mark on a piece of paper, dampen your finger and draw it across the mark. If the ink smudges you will know it is not waterproof.

Now let's start our drawing. As well as the felt pen you should also have a container of clear water and a clean paint brush. First, draw your subject, but do not put in too much detail because you will be adding this with the brush at the next stage. Look at the top drawing of the dog in **fig. 77**: these are the only marks I made with the felt pen. When the drawing is done, wet your brush and draw it along so that it touches the inside edges of the lines. You will find that when you place the wet brush on to a line, the brush will soak up and contain some of the colour. This can then be used to apply a wash on selected areas such as the nose and the top of the dog's head. When you come to an area such as that around the eye, touch the drawn line with the point of your brush and proceed to pull out the colour in the direction you want it to go. This technique is difficult to control and needs practice to achieve satisfactory results.

Fig. 78 illustrates the second technique for using felt pens. I have seen designers discard felt pens as soon as they begin to dry up, but I keep them until they almost completely dry up and are barely capable of making any mark at all. This is not due to thrift or meanness on my part, but to the fact that an interesting, subtle effect can be achieved by using such pens, as the drawing shows.

When I was doing this drawing, one of the pens I was using was so dry that I had to stop on two occasions to allow the tip to soak up what little moisture was left in the pen before I could continue. This was perhaps a little *too* dry – it's annoying if you have to pause in the process of drawing – but it is important that your pen is dry enough to give the quality of line which you can see in **fig. 78**.

Fig. 78

Finger and Ink

This is a technique which can be used to good effect, particularly on a subject like the iguana below (**fig. 79**). Start by practising the basic technique to see what effects can be obtained. Draw several lines of various thicknesses and dab them with your finger. For example, I drew three similar lines (**fig. 80**) and dabbed the first immediately; I waited a little while before dabbing the second; and I waited too long before dabbing the third – the ink had dried! The secret is to know how long to wait before dabbing the ink with your finger.

Fig. 79

A thin line containing little ink will dry very quickly and therefore needs to be dabbed immediately after application (**fig. 81**). Try dabbing the line once only, then try dabbing it several times and maybe moving the position of your finger very slightly to the left or right of the line. Try also repeating your drawn image (**fig. 82**). Here I drew four small curved shapes then dabbed them by keeping my finger flat on the paper and quickly moving it to the right and left of the original drawn shapes.

Experiment with the medium; find out what you can do with it. If the ink dries too quickly, draw over it; conversely, if it is too wet, you can always cover up unwanted areas with white paint. You can also use white paint to pick out any highlights. I did this on some of the scales of the iguana. Use Permanent White, which is opaque, and not Zinc White, which is less so and is better used for mixing with other colours in order to lighten them.

Fig. 80

Fig. 81

Fig. 82

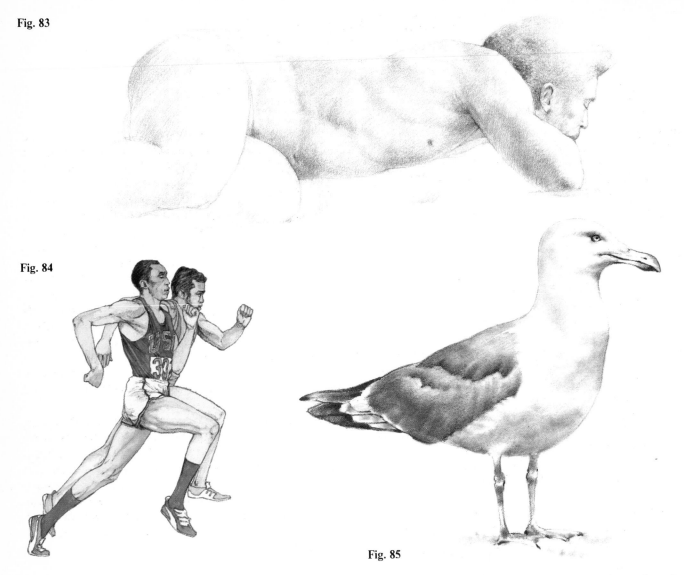

Fig. 83

Fig. 84

Fig. 85

Pencil

This is the most popular medium used in drawing. Pencils are inexpensive and can be purchased in many shops and stores. The range is enormous and includes not only lead pencils, ranging from very hard to very soft, but also carbon and wax ones, not to mention pastel, charcoal and coloured pencils, which are dealt with separately in other sections of this book.

The lead pencil (or, I should say, what we *call* the lead pencil) actually contains no lead at all, but is made up largely of graphite. Details of the range are given on page 10. The pencil is one of the easiest media to use: no preparation is required, no additional equipment. You just need a pencil and paper and you are all set to start your drawing. It is my favourite medium.

I like to use a soft rather than a hard pencil – a B or 2B for the smaller to medium-sized drawings, and a 4B or 6B for larger work. The softer half of the range gives more flexibility. If I want a light, delicate line, I

use only gentle pressure, increasing it when a heavier, darker line is required.

When shading I draw a series of diagonal lines, placed closely side by side. For a denser effect, I either repeat the process by adding darker strokes over the first pencil lines, or gently 'rub' the pencil over the surface of the paper, increasing the pressure to produce darker areas where required, as in **fig. 83**. I like to work on a medium-grain cartridge paper, as I find the slightly grainy texture gives some 'bite' to the pencil. The kind of paper you use depends, of course, on the effect you are after.

The reclining figure drawing (**fig. 83**) was done on a fine-grain cartridge. The two athletes (**fig. 84**) were drawn with a carbon pencil on to rough cartridge before various watercolour washes were applied. The seagull (**fig. 85**), on the other hand, was drawn on a smooth-surfaced cartridge and then rubbed with a French stick to produce the characteristically smooth appearance of the gull. Highlights were then produced with a putty rubber.

EXERCISE ONE
STILL LIFE

The intention of this and the following exercises is to show you, by example, how to develop your drawing from the first measurements through to the final stage. I have included as many different subjects as possible in the space allowed, and although the same basic principles apply to whatever you are drawing, I have repeated certain instructions, particularly in the early stage of drawing each subject. This is done deliberately: first, so that the relevant information will be available to you whichever exercise you decide to tackle first; and second, because it is good practice to go over the basic information repeatedly. By doing so, you will find it becomes more familiar.

The first drawing here (**fig. 86**) deals with getting the correct proportions, and the second drawing (**fig. 87**) concentrates on adding the details. In this still life composition I have included some difficult objects, and because of this you will need many guidelines in order to help you position and proportion the objects accurately. Don't be discouraged by the complicated appearance of the drawing. This was built up step-by-step, and you can use more, or fewer, guidelines as you feel necessary.

After you have arranged the objects in a pleasing composition, decide what you are going to use as a standard unit of measure, as described on page 14. In this case, I chose the distance between the base of the fitting at the top of the saltcellar and the base of the sphere (**fig. 86, A**). I then lightly drew the sphere with the fitting in place.

Next I drew a vertical line (**B**) through the centre of what would eventually be the saltcellar, and down through the rest of the area which would contain the group. I then measured the group to find out how many of the standard units made up the composition. There were just over seven units and I transferred this information to my drawing, as you can see on the left-hand side. By drawing horizontal lines through each of these points I could ascertain, as near as possible, the position and height of each of the other objects in relation to the saltcellar.

To work out the width area and position I drew a horizontal line four units from the top (**C**) and divided this in the same way as the vertical line.

From these two basic guidelines (**B** and **C**) I was able to use the measuring unit (**A**) to plot the positions and proportions of the details of the various objects. Having established these, the next stage was to connect these points by drawing the form of each object (**fig. 87**), and to block in the shaded areas to indicate the direction of the light. Once you have reached this stage in your drawing it is ready to be finished in your chosen medium.

Fig. 86 First stage

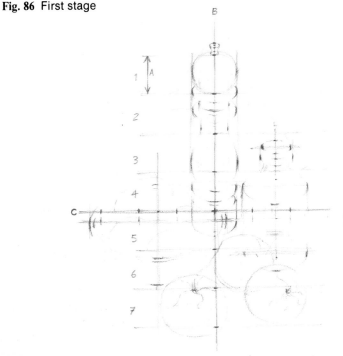

Fig. 87 Finished stage

I decided to concentrate on cylindrical objects for this still life drawing (**fig. 90**), particularly as they are so commonly found in the home. I also decided to include an item which had a glossy surface (the jar), and a shiny metallic object (the plant spray) as many artists find these surfaces difficult to produce convincingly.

While studying the group first, I decided pastel would be a good medium to use, primarily because of its opaque quality, but also because if I wanted to alter slightly the proportion of the apples or the cloth on which they were standing, this could comfortably be done at the blocking-in stage. You may say that this is a contradiction of my earlier statement in which I stressed the need to get the proportions worked out correctly at an early stage. Not so. Objects like apples come in a variety of shapes and sizes and are not perfectly round, so slight adjustments are possible. This applies also to a piece of cloth. It is a different matter, however, when it comes to altering a part of a human figure, an animal, a vehicle or any man-made symmetrical object. For example, let's say that you have to make the legs of a figure longer. Because of these adjustments you might then discover that the head appears too small, and so the problems would mount up until you'd find yourself struggling in a piecemeal fashion to balance all the proportions.

The first thing that I noticed about this grouping was that the jar occupied a position slightly to the left of centre. You can see what I mean more clearly if you look at the finished stage (**fig. 90**), which is the view I had. Holding my stick of pastel vertically at the centre of the group gave me a visual guide as to where the centre line of the jar should be drawn on the sheet of paper (**fig. 88, B**). I used the distance from the top of the jar to the rim at the base of the neck as my measuring unit (**fig. 88, A**). Using the centre line as a guide, I drew the neck, which meant I was then able to work out how many of these units made up the length of the group. With this guideline and measuring unit, I worked out that the shoulder of the jar was exactly two units from the top (**C**), and that the centre line of the water spray was two units to the right of the centre of the jar, which enabled me to draw in the line **D**. By studying the drawing carefully you will see how the rest of the proportions were worked out.

The next stage (**fig. 89**) was to block in the basic colours. When you do this, start with the darkest colours, which you will find in the shaded areas. For instance, if the object is, say, brown, block in with the darkest shade of that colour over virtually the whole area of the object. Then build up the three-dimensional form by laying the lighter colours on top.

The final stage (**fig. 90**) was taken up with continuing the build-up of the surface colours, refining the shape and colour of the objects, and finally adding the highlights.

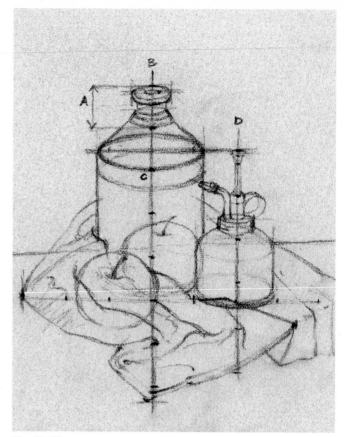

Fig. 88 First stage

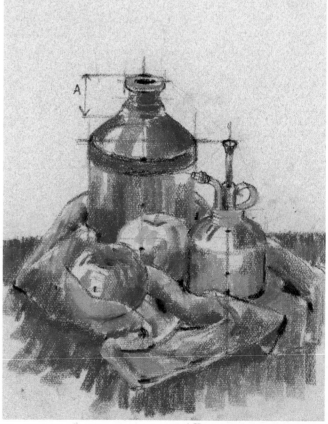

Fig. 89 (*above*) Second stage **Fig. 90** (*right*) Finished stage

44

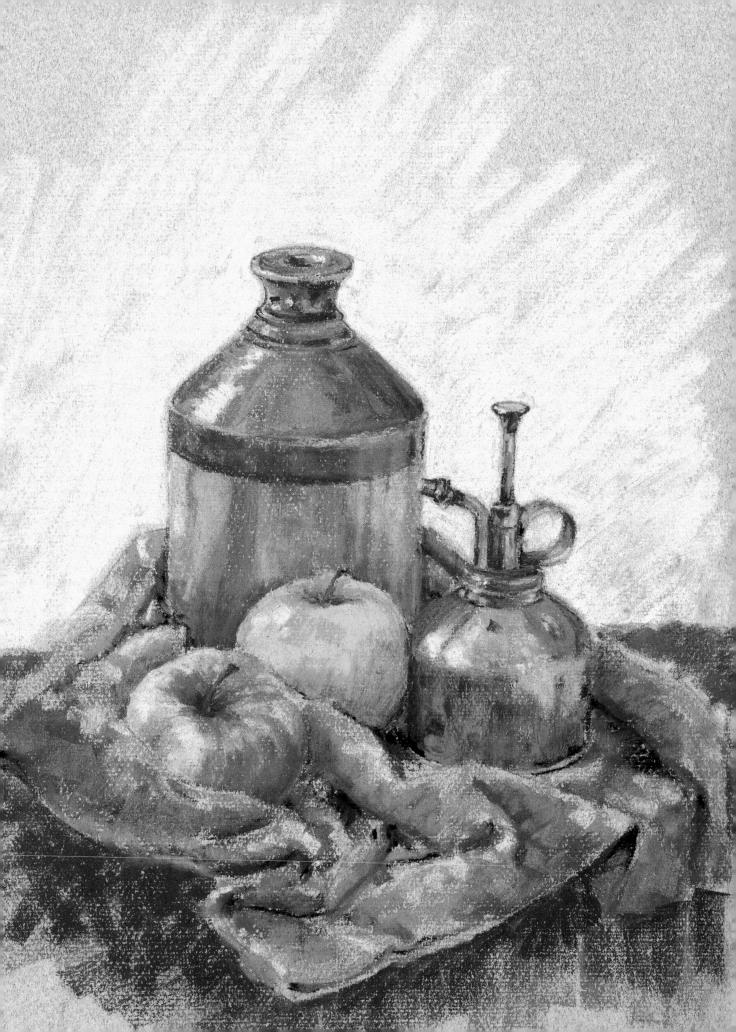

EXERCISE TWO
THE HUMAN FIGURE

Before starting any drawing you should first look at your subject very carefully. Study the form, proportions, line movement, construction and size. It's no good, for example, making a detailed drawing of a head only to find as you progress down the body that you have not left enough space on the paper to complete the drawing. You must work out the proportions in advance. So how do you make sure that the drawing you intend to do will fit nicely on to the sheet of paper or board?

Look at **fig. 93**, which is the view of the figure I had before starting. I decided to draw a vertical line through the approximate centre of the figure (**fig. 91, A**). Then I held my pencil at arm's length, lining up the top of the pencil with the top of the head, and placing my thumbnail on the pencil to line up with the chin (see page 14). Keeping my thumbnail in that position, I moved the pencil down the figure to find out how many heads were contained in the whole length of the body. There were just under seven heads. I next divided the vertical line (**A**) into seven equal parts, making sure that I could fit all seven within the area of paper on which I intended to do the drawing, and then drew a horizontal line through each point of division (see the left-hand side of the figure). This gave me the size of the head (**B**), which I drew in roughly, noticing that the eyes came approximately halfway down. With this information I was able to establish the position of the remaining facial features.

The head could now be used as a measuring unit to work out the position of the other parts of the body. I measured out a head length (**C**) each side of the vertical line to help me establish the width of the shoulders. I also discovered that a diagonal line drawn from the eyes down through the point of the shoulders ran through to the elbows. Note how because the body was slightly turned away from me, and because I was sitting and therefore my eye level was along the line of the hands, the line across the shoulders sloped slightly down. On the other hand, the lines through the knees and feet sloped slightly up (see pages 16 and 18 on perspective, eye level and vanishing points).

By observing and measuring in this way and drawing in guidelines and points, I was able to build up a framework on which I could draw in the outline of the complete figure (**fig. 92**). The last stage (**fig. 93**) was taken up with finalizing the details and moulding of the body shading. I decided to use a minimum amount of shading, just enough to show the form.

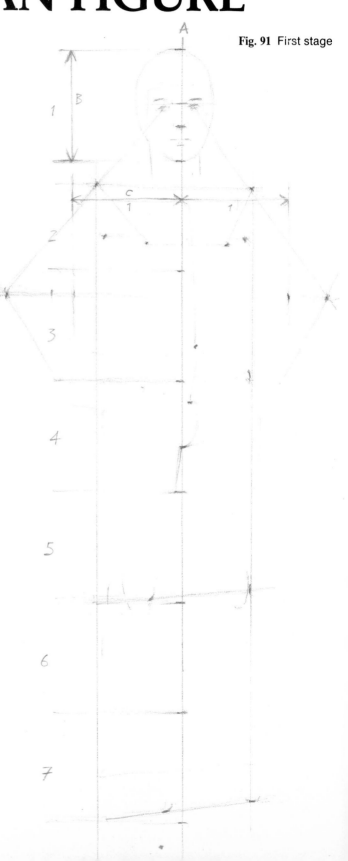

Fig. 91 First stage

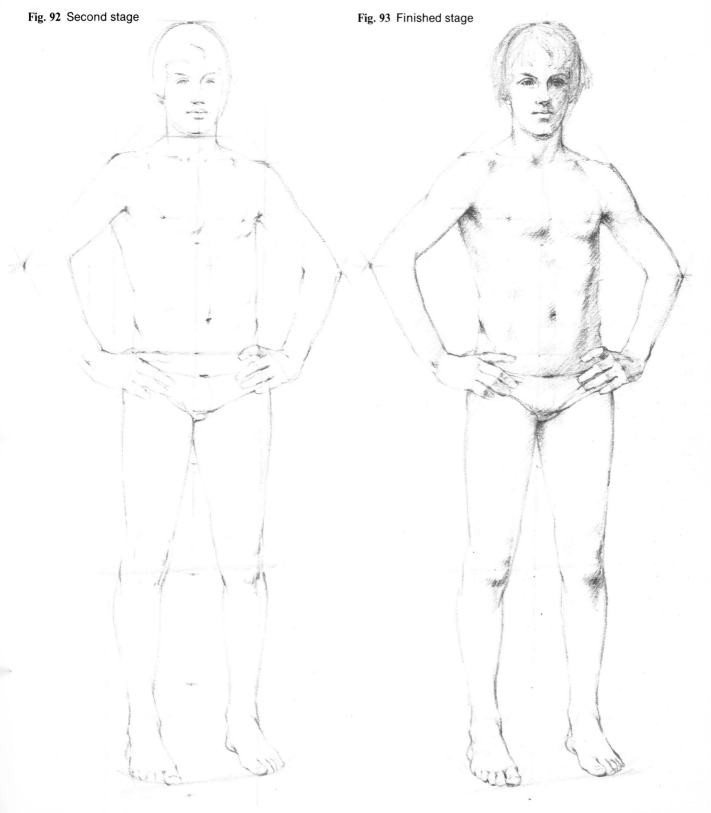

Fig. 92 Second stage

Fig. 93 Finished stage

Fig. 94

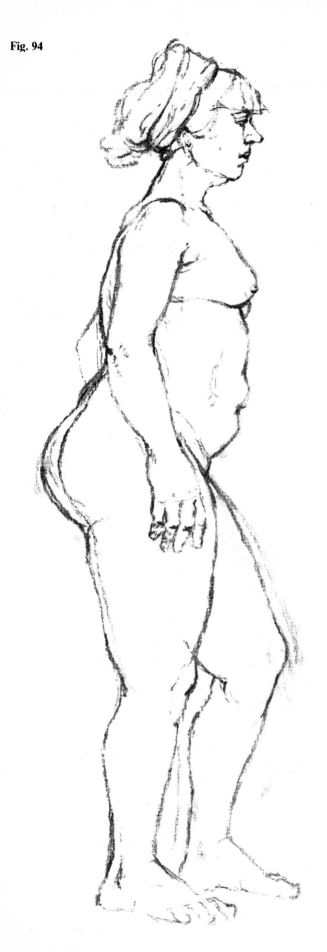

There will come a time when you feel confident enough to dispense with the measuring system which I have been advocating throughout this book, and to draw by observation only. Many artists do, as they find this gives them more freedom of expression, only reverting back to the measuring system when they feel it necessary to sort out certain areas that they are unsure of, or when they do not trust their powers of observation. A case in point is the charcoal drawing in **fig. 94**. The idea of an exercise like this is to work quickly and draw a figure in a specified time. Sometimes this can be as short as thirty seconds, at other times five, ten or fifteen minutes. It's an exercise devised to test your powers of observation, thereby proving to yourself just how much, or how little, you have improved in this respect.

One always has a tendency to draw the human form as one thinks it should look and not as it really looks. I made this mistake as I was drawing **fig. 94**. When I had completed the drawing I felt that there was something not quite right about it. On carrying out some quick measurements to check the proportion, I discovered that I had slimmed down the area around the buttocks. The original line I drew can be clearly seen along with the corrected, more accurate line. This exercise taught me a lesson. When working on a subject like this, you do not draw to flatter, you draw to learn. To do that you must draw accurately, mentally gathering the relevant information as you work.

The point I am making is that you should always use the measuring system during the early stages in your artistic development. By that I do not mean just over the period of your first dozen or so drawings, but a period which could span a number of years! Even when you do reach a stage when you feel you have learned enough to work without measuring, don't discard the method entirely, but use it periodically to check your work. I have no doubt that there will be occasions when you will *have* to use the method due to the involved and complicated type of work you are bound to come across.

Fig. 94 was done with a thin stick of willow charcoal on a light-coloured Ingres paper. Notice the movement in the line of the body: back from the top of the head through the neck to the shoulders; slightly forward to the abdominal area; down and back towards the buttocks; and then down through the leg.

The drawing of the seated figure (**fig. 96**), involves a sharp change in the direction of the body, bringing into play a variety of angles. As with the previous drawing, the first thing to do is to determine the area taken up by the figure. Therefore, draw a vertical line (**fig. 95, A**) and work out how many heads make up the length of the body (remember the instructions on

page 46). In this case there are less than four heads. Transfer this information to your drawing by dividing the line into four equal parts, drawing a horizontal line through each divisional point. Now repeat this procedure along a horizontal line which cuts across the length of the legs (**C**). This will give you a more accurate idea of the area taken up by the figure.

If you hold your pencil horizontally at arm's length you will see that the chin just about lines up with the shoulder on the right; mark this in on your drawing. Also, note that the base of the arm joins the body exactly one and a half heads from the top. Now hold your pencil vertically along the line marked **A**. Slowly run your eyes down the pencil, taking note of the angles and positions of the various parts of the body in relation to the line, and mark these in on your drawing. Repeat the process using the horizontal line.

When you have drawn in the relevant points you can then check the proportions by using the head

measuring unit. You'll see, by holding a pencil diagonally, that the toes, knee and waist area at the rear of the body line up. When drawing, continually compare proportions, such as the width of the arm compared to that of the leg, and the width of both to that of the face – and what about the length of the foot in comparison to the length of the head? In other words, check and crosscheck wherever you can, and you will then have a chance of producing a well-balanced, well-proportioned drawing. Look carefully at the planes and angles within the figure, too. You will notice that the head is forward and turned towards the viewer, which puts it on a different plane from the rest of the body. This has the result of making the angle of the facial features more acute than that of the shoulders (**fig. 96**).

I used a dryish felt pen on rough cartridge paper to do this drawing, which gave the lines a broken, textured quality.

Fig. 95 First stage

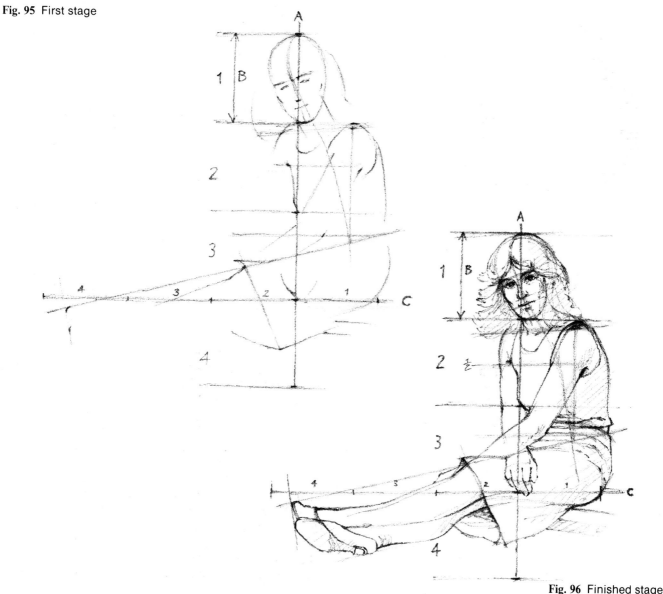

Fig. 96 Finished stage

49

EXERCISE THREE
ANIMALS

Those of you who are fortunate enough to live within easy travelling distance of a zoo will have endless possibilities when it comes to finding excellent models for your drawings. For example, an orang-utan, once it gets into a comfortable position, will stay there for quite a considerable time – certainly long enough for you to carry out your measuring, put in your basic lines, and draw in the details required to carry the drawing to a reasonably finished stage.

To draw the orang-utan in **fig. 99**, I decided to use charcoal on a very rough cartridge paper, which would not only give me the texture I required, but also convey the undoubted strength of the creature.

I first drew the vertical line you can see in **fig. 97**, then divided this into the number of heads which made up the ape's body (slightly over three), in the same way as in the previous exercises. I decided that the base of the vertical line would be the point at which the two feet met. Looking at the model and holding my pencil vertically at arm's length, I positioned the bottom of the pencil exactly at this point. By looking up the length of the pencil I was able to see the position of the various features, particularly the head, in relation to the vertical line. I noticed that the nose was just to the left-hand side of the vertical line, and that the distance

from the top of the head to the top of the nose, just above the nostrils, was exactly half a head. This gave me the exact position of the nose. Holding the pencil *horizontally* across the nose showed that it lined up with the bottom of the ear, and that the centre line of the ear was half a head from the vertical line. The next discovery was that the mouth was exactly half the distance between the nose and the chin. I now had the positions of the top of the head, the chin, nose, ear and mouth, and with this information I was able to draw a rough outline of the head. I carried on in this way until I reached the stage illustrated in **fig. 97**. Study this carefully to see how the other points were worked out.

You may think this all sounds very complicated and time-consuming, but once you understand and practise the procedure you will be able to do it quickly.

Having worked out the proportions, I was then able to make a detailed drawing of the animal (**fig. 98**). The final stage (**fig. 99**) was produced by snapping off a piece of the charcoal and using the side of it, lightly moving it across the surface of the rough paper. This technique gave me a rough, broken, grey texture. I used the end of the stick of charcoal to accentuate the features and draw the hair which covered a large proportion of the body.

Fig. 97 First stage

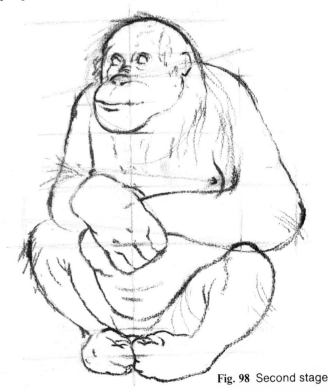

Fig. 98 Second stage

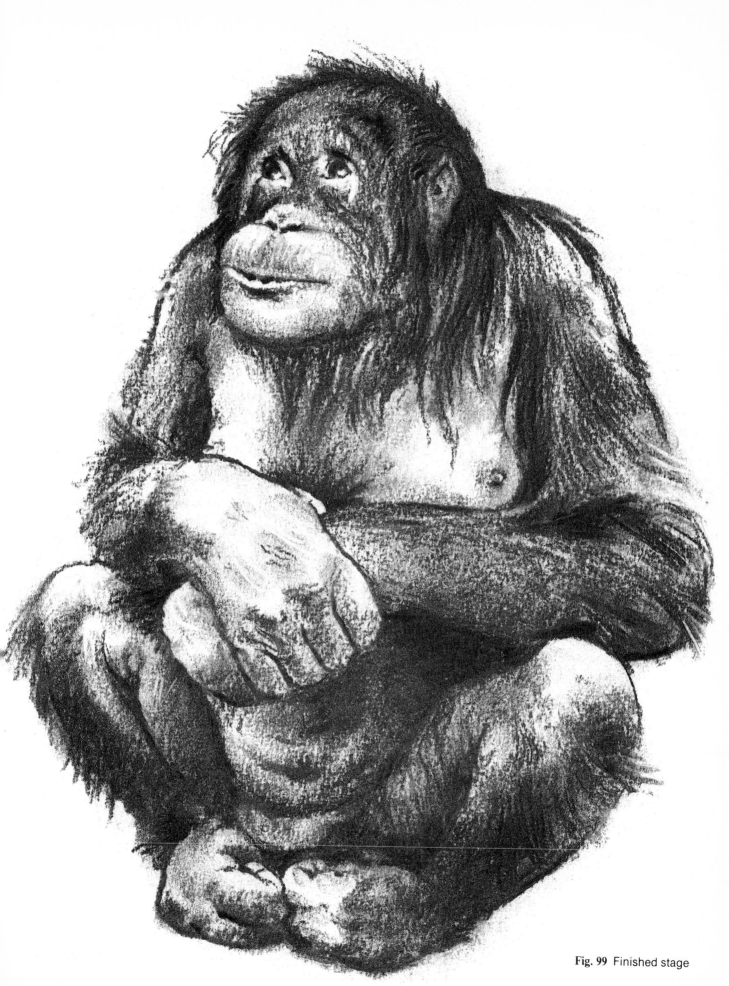

Fig. 99 Finished stage

Drawing an animal such as a deer (**fig. 101**) is more difficult: they tend not to stand in one position for very long, so you have to work quickly. Look carefully at your subject and make mental notes of the proportions and basic shape. If necessary, use your pencil vertically and horizontally to check the movement and position of various points. Then transfer to paper as much of that information as memory allows. Keep repeating this process until you have completed the basic drawing.

If the animal moves before you have finished, you have two choices. You can either start again on a new pose or patiently follow the animal until it assumes the same pose, thus enabling you to carry on and finish the drawing. A method that I find works quite well is to start a fresh drawing on the same large sheet of paper each time the animal moves. You will then have three or four drawings which you can carry on with if the animal resumes any of those positions again.

It would be a mistake to start by painstakingly drawing in the details of your subject, maybe spending several minutes or so on the head alone, because the animal is certain to move its position long before you even get halfway to completing the work. **Fig. 100**, for example, was done by quickly drawing in the basic shapes: no time here for working out in detail the position of each point and feature of the animal as I did with the orang-utan in **fig. 99**, but enough to check the vertical and horizontal lines of the pose (**A**). I drew in the features in detail by moving my own position as the deer moved.

The drawing was done with a brown coloured pencil and then a light wash of watercolour was applied (**fig. 101**), which you can see on the farthest antler and right front and back legs (**B**). This was gradually built up by laying one light wash upon another (varying the strength of tone to conform with the modelling), to the stage shown on the front left leg, the right-hand side of the body and the right antler (**C**). The drawing was completed by using coloured pencils to accentuate the details of the modelling and features (**D**).

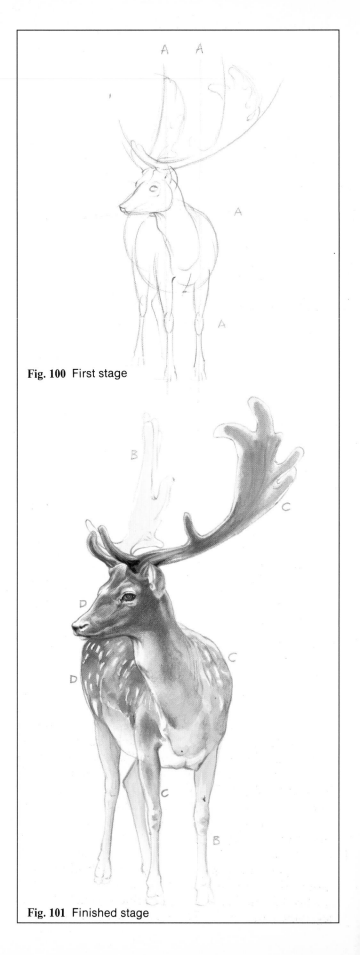

Fig. 100 First stage

Fig. 101 Finished stage

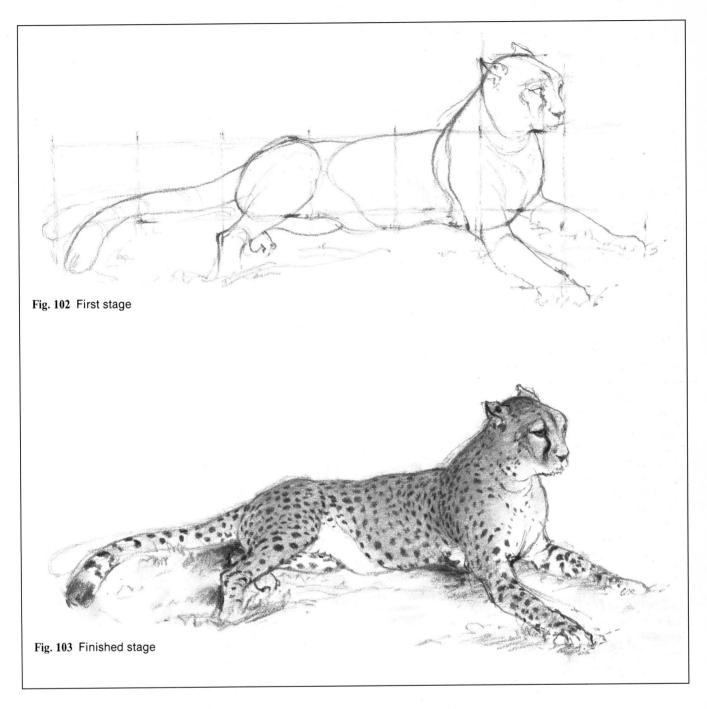

Fig. 102 First stage

Fig. 103 Finished stage

Fig. 103 was drawn with two pastel pencils, using the same method as for the orang-utan (**fig. 99**). First I drew in the head, because once that was done I was able to use it as a unit to work out the length of the body and tail (**fig. 102**). Next I drew in the horizontal line which you can clearly see running along the back, connecting the chin to the hip. This was divided, using the head as a measuring unit (see page 14), and by holding the pencil vertically at these points I was able to determine the position of various parts of the body. Notice that by following down the line at the back of the head I could establish the point at which the front leg joined the body. Three head lengths away from

this gave me the position of the heel of the back leg, and another head length away gave me the point at which the tail begins to bend forward. In this way I was able to build up an accurate framework of guide-lines which, once all the relevant features of the cheetah had been drawn in, could be erased.

The drawing was then completed using a warm-brown pastel pencil (not sharpened to a fine point) to capture the colour of the animal (**fig. 103**). This was applied quite freely by rubbing the colour over the rough surface of the board. I felt this technique gave a more satisfying texture to the coat of the animal than single strokes would have done.

EXERCISE FOUR
PLANTS

Drawing plants demands just as much care and attention as any other subject matter; in fact, I would say a keener sense of observation is required because of the asymmetrical appearances of plant forms. Look, for example, at the flowers illustrated here. The basic construction and colouring are the same for each, but there are subtle changes in the details and shapes.

Each species of plant is unique, its character being defined by its size, shape, colour and constructional pattern. It is therefore particularly important when drawing any plant to ensure that the proportions of the flower are correct in relation to those of the leaf, etc. Constantly compare the proportions of each part of the plant when constructing your basic drawing.

Because each plant has so many different parts, it would be unrealistic (when working out the basic shape of your plant) to use the detailed measuring method described in Exercise One. Instead, you will have to rely a great deal on your observational expertise to produce a rough drawing of the plant.

In **fig. 104** I started by drawing a vertical line (**A**). I then held a plumb line (a pencil would have obliterated the stem from my view) up in front of me so that I could judge the curving movement of the stem and represent this accurately on the paper. Then I visually divided the length into three main sections (1, 2 and 3). I checked and corrected these by using the first area (1) as a measure. Using these divisions as a guide, I roughly drew in each element, concentrating on just the basic shapes at this stage.

I used coloured pencils for this study, so the basic drawing was done with a light grey one. A dark lead pencil would have been too strong and would have shown through on the finished drawing, destroying the soft quality of the flowers and leaf edges. As it was, I still had to dab the pencil lines with a putty rubber before introducing colour to the work.

Details were drawn in next, using the primary colour of the various components (**fig. 105**). The lightest colours were applied first, and then I progressed through the deeper hues, eventually finishing with the darkest colours. This is because of the transparent quality of the medium.

A number of different colours need to be used if you want the finished work to have a rich depth of colour (**fig. 106**). You *can* produce a three dimensional effect by varying the tones of one colour, but it will lack that visual richness. No less than thirteen colours were used to produce the finished illustration here (see opposite).

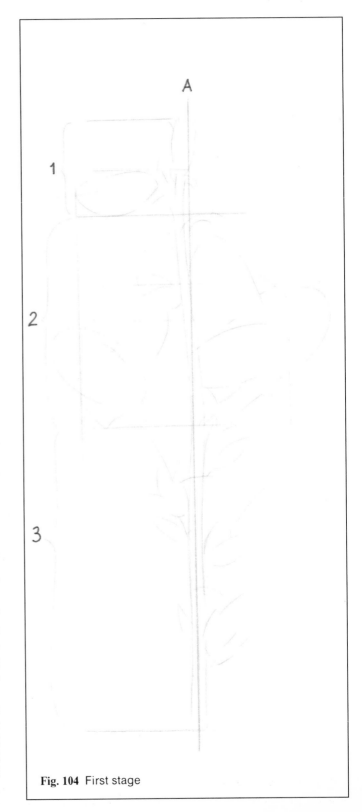

Fig. 104 First stage

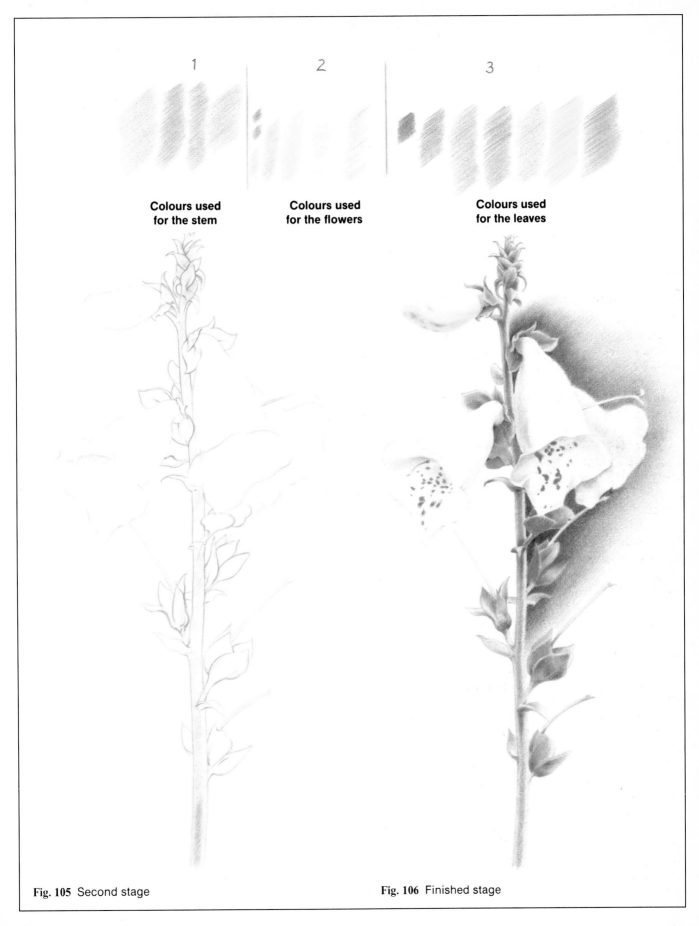

1

2

3

**Colours used
for the stem**

**Colours used
for the flowers**

**Colours used
for the leaves**

Fig. 105 Second stage

Fig. 106 Finished stage

Fig. 107 First stage

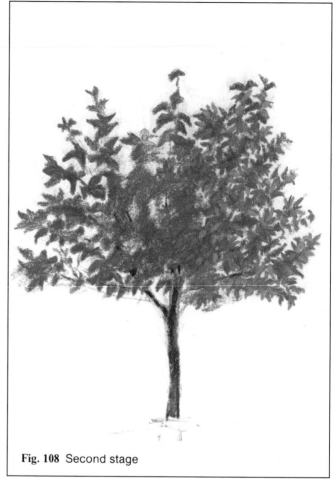

Fig. 108 Second stage

On the two previous pages we have concentrated on drawing a close-up view of one particular section of a flowering plant. We will now deal with a complete plant – in this instance, a young tree. Many gardens contain trees like this so you should not have much difficulty in finding a suitable subject. Remember, incidentally, to bear in mind that a tree is not *just* a tree: it is either an oak, beech, sycamore, pine or lime, etc. Each has its own characteristics and its own structural growth pattern and colour, so if you are working on a landscape, you must differentiate between the trees contained in it in order to give it that authentic quality which makes it believable to the viewer. By this, I do not mean that you should meticulously draw in each leaf and detail – that would be impossible – but the general character of the tree must be shown, even if it is in the form of a silhouette in the distance.

It is not surprising that many amateur artists, when confronted with the task of drawing a tree, feel that it's too complicated and don't know where to begin. All they can see is an intricate abstract shape of thousands of individual leaves with occasional glimpses of branches. The step-by-step method described here, however, should prove helpful.

First, look at the finished drawing (**fig. 109**); it will help if you continually refer to this as we go through each stage. I could see the trunk quite clearly so this was the first thing I drew (**fig. 107**). Then, looking carefully at the position and pattern of the leaves, I was able to work out the direction and length of the main branches, filling in the area where this was not possible. With a dark green pencil I then proceeded to develop this basic structure (left-hand side of **fig. 108**), using a dark brown pencil for the trunk and the thicker branches. Most of this would later be covered, although appropriate parts would remain to represent leaves in shadow.

The middle tones were then introduced by using two lighter greens (right-hand side of **fig. 108**). You can now see the three-dimensional form of the tree beginning to take shape. Finally, light greens were added to complete the foliage, and light browns to finish the trunk (**fig. 109**). Remember, don't try to draw each individual leaf, but do make sure the size of the leaves is in proportion to the size of the tree, and arrange them so that they correspond to the growth pattern.

This drawing was done with pastel pencils on a fine-grain cartridge. If you find, when adding a light colour, that it mixes with a dark colour underneath, fix the

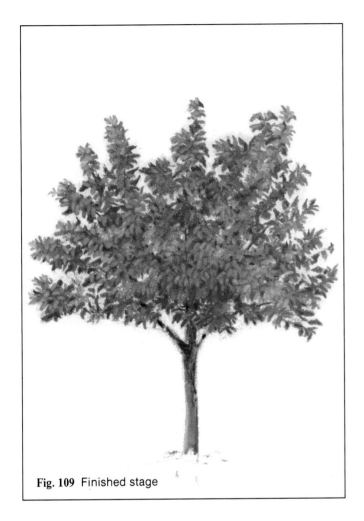

Fig. 109 Finished stage

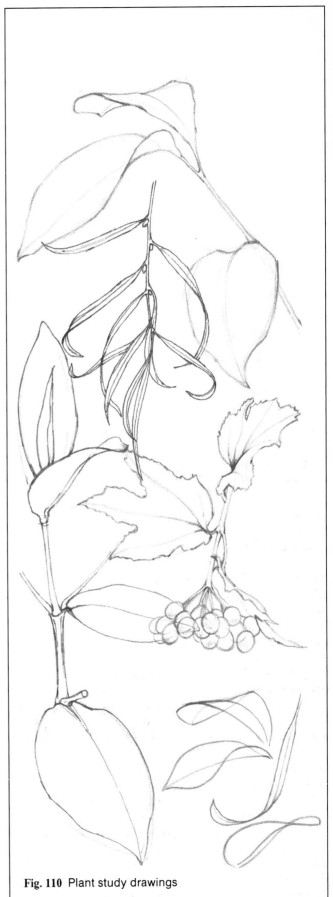

Fig. 110 Plant study drawings

dark colour first. If necessary you can repeat this process at each stage of the drawing.

Plant drawing is a fascinating subject from which you can derive a great deal of pleasure. If your intention is to specialize in this subject, you will need to do a great deal of research in the form of study drawings in order to ensure success.

There are a vast number of botanical and gardening books on the market which are useful for acquiring knowledge of the many plant forms, but the best method by far is to draw from life. The obvious place to start is in the garden – your own or a friend's. Or you can visit a garden centre – I am sure that the owner would readily give you permission to use the centre for your studying. A trip to a botanical garden would also prove invaluable.

Start by making detailed drawings of the various flower and leaf forms (**fig. 110**), writing the name beside each study, and also include notes on the colour (ideally, by actually applying the colour to your drawing), the size of the flowers and leaves, and any other relevant information. Keep a number of sketchbooks especially for this kind of research, using one for flowers, one for shrubs, and another for trees, etc.

EXERCISE FIVE
LANDSCAPES

One of the advantages of drawing landscapes is that you can get to work out of doors. I can think of nothing more pleasurable than to be seated in a field, or on a hillside, or in a wooded area, listening to the bird calls and the hum of insects on a warm day with just the hint of a breeze, drawing the countryside around you. The trouble is, you sometimes have to force yourself to get down to doing some work instead of just sitting there drinking in the atmosphere!

The choice of scene, of course, is a personal thing. You may have a particular place in mind before you leave home, perhaps somewhere you have visited in the past or seen on your travels. On the other hand, you may decide to drive out into the country on the chance of coming across some place or view which interests you. Popular choices with many people are often an old church, a panoramic view across miles of country with maybe hills or mountains in the background, or a riverside or lakeside. If the view you have chosen does not include buildings, you will have to use tonal perspective to create the feeling of distance.

For this exercise I chose a derelict farm building framed by trees in the background (**fig. 113**). The foreground is broken up by areas of wild flowers and a small pond. I worked on Ingres paper, using pastels from Daler-Rowney's 'Beginners' Kit' (see page 10).

Before I started drawing, I studied my subject carefully. Always remember to do this. I noticed that the apex of each roof did not adjoin the adjacent building centrally, which was unusual because the side walls of each section of the building aligned exactly. The first thing I needed to do was to establish the position of the eye level, by holding my pencil horizontally before my eyes as described on page 16. I then observed that the base of the two windows of the barn lay just below the eye level (**fig. 111**). This was good, for I now had a position for my first structural features. I drew a line across the paper to represent my eye level and lightly drew in the windows. I now had a convenient measuring unit (the right-hand edge of the window, **A**) with which to work out the positions and proportions of the other components. I discovered the ground level was one unit below the base of the window, and that the top of the chimney was a little over six units up from the window base. By holding the pencil vertically along the nearest edge of the chimney, I was able to see that the edge lay slightly to the right of the window. By now I had enough information to be able to position the chimney accurately. Continuing in this

Fig. 111 First stage

Fig. 112 Second stage

way, plotting the positions of all the key elements of the composition, I was able to complete the basic drawing (**fig. 111**).

The next stage was to block in the basic colours (**fig. 112**). Try to avoid the temptation to put in the surface colours at this stage. I like to look beneath them and put in the darkest colours first, working over with the light ones later. Do not attempt to work up and complete one section of your drawing at a time; work over the whole area, so that you achieve con-

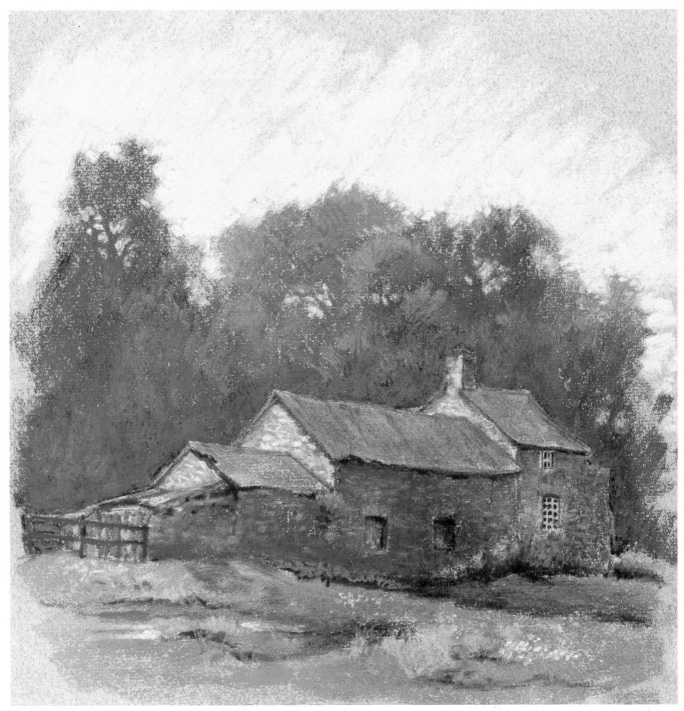

Fig. 113 Finished stage

tinuity of colour and tone. Block in the shaded areas first to establish the direction of the light.

This is the point at which some people get discouraged because they feel that the whole thing looks a bit of a mess. But you must remember that this stage establishes a base on which you are going to build. So do not rush it; think carefully about the colours, the light, etc., and don't make the mistake of being in too much of a hurry to get to the final stage. You will find, in fact, that in a drawing like this there is no definite point at which one stage finishes and another begins. It is a gradual progression.

The completed work (**fig. 113**) was arrived at in this way, by gradually laying one colour over another until the required colour and tone was achieved. There is a limit, however, to how much pastel you can apply before reaching a saturation point. This can happen if too many colours are used on top of one another. In this situation, you will have to fix that area before you are able to continue.

Fig. 114 First stage

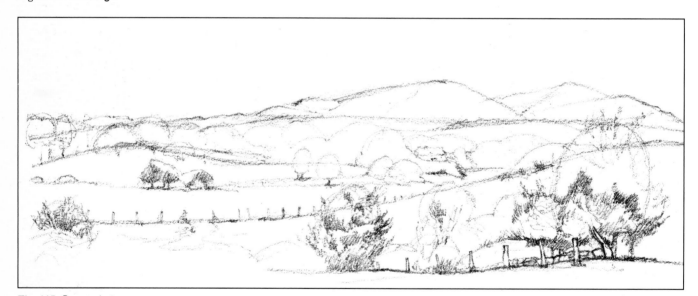

Fig. 115 Second stage

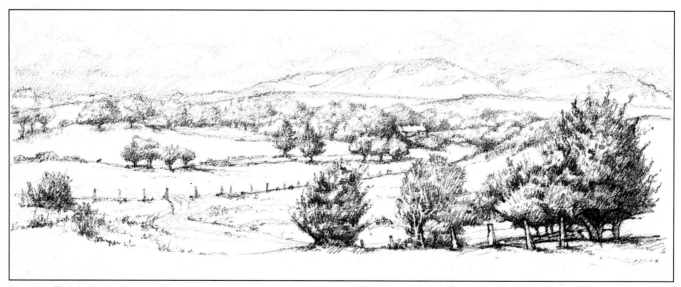

Fig. 116 Finished stage

The intention here is to show you how to tackle the problem of drawing a landscape where it is not advisable, or indeed possible, to call on the aid of perspective in order to help you work out the position and size of the various elements contained in the scene.

Look first at the completed pencil sketch in **fig. 116** to familiarize yourself with the scene which confronted me. By comparing this with the first stage (**fig. 114**), you will see how I started the drawing by concentrating on the basic lines, ignoring the details. I did this visually as there is no point in using the measuring method on subject matter such as this. It doesn't matter if a section of a field is made slightly larger or smaller than it actually is, provided that the overall balance is pleasing to the eye. Nevertheless, do be as accurate as possible by constantly comparing the proportions of one section of your drawing with another as you work.

Having drawn in the basic lines of the landscape in this way, I was now able to indicate the position, size and shape of the trees in a similar way (**fig. 115**). Next I started to introduce the details, the first stages of which you can see in the foreground of **fig. 115**. Keeping in mind that I needed to use tonal perspective in order to emphasize the distance involved, I gradually developed the sketch by working from the foreground through to the background (**fig. 116**). It is easier to control the tones by adopting this sequence for it enables you to establish the correct strength of the foreground, and then gradually lighten the tones as you work back through the middleground to the background. If you were to reverse the procedure (starting with the background and working towards the foreground) there would be a danger of making the background too strong, thereby reducing or even cancelling the atmospheric effect of distance.

Fig. 118 was started in exactly the same way as **fig. 116**. The basic areas were drawn in line, but then a brown ink wash was applied (**fig. 117**). The ink was used straight from the bottle for the dark areas and diluted with water for the lighter tones. Always use a palette when diluting ink, for you can then gradually add a little of the ink to the water until you get the tone you need. This method gives you complete control. Never dip a brush full of water directly into the bottle as this would eventually have the effect of diluting the whole bottle, thereby destroying the brilliance and strength of the colour. In the case of black Indian drawing ink, this has an adverse effect on the actual composition of the ink.

When the ink wash had dried I put in the details, using white, grey and brown pastel pencils (**fig. 118**). I must confess that I encountered some difficulty when fixing the work as the fixative had a diluting effect on the pastel, which meant I had to redraw certain parts. I hope you can still see the details sufficiently here.

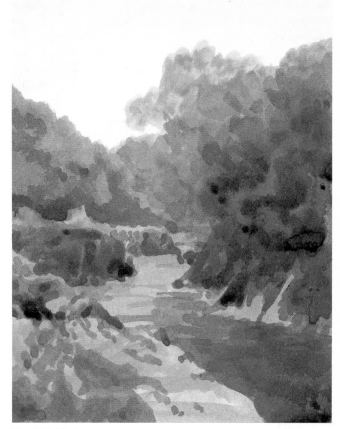

Fig. 117 First stage

Fig. 118 Finished stage

EXERCISE SIX
VEHICLES

Drawing man-made objects is made easier by the fact that perspective can be used in a more positive way. Receding lines are more obvious and therefore we are able to use the eye level and vanishing point, or points, to help us in the construction of our drawing. **Fig. 127** is a good example of this. There are, however, many objects to which the laws of perspective can be particularly difficult to apply, and I have included some examples of these in this section.

It is not possible in the limited space available here for me to go through each detail involved in working out a complete drawing, but the information in each of the exercises in this book should provide you with all you need to know to complete your drawing successfully.

Compare the finished drawing in **fig. 121** with **fig. 119**. You will notice the fixed symmetrical points which I have used to help me construct the drawing: the obvious one is from the point of the bows, back through the boat to the centre of the stern. Another goes across the width of the stern itself through the two corner points. This determines the points where the rail supports are attached to the deck. In this drawing there is a choice of three measuring units: you could use the distance across the stern (**A**), across the corners of the cabin top (**B**), or the length of one of the rail supports (**C**).

To establish the angle at which the vessel is lying, hold your pencil horizontally in front of you across a point such as the nearest corner of the cabin. If you draw in a line (**D**), you will notice that it cuts through the base of two of the rail supports. By using this method of establishing key points, in conjunction with the unit measure, you will gradually build up your drawing as in **fig. 119**. Once you have done this you will be able to finalize the shape and details as in **fig. 120**. I chose coloured pencils to complete the drawing as the soft quality of the medium helped to portray a warm, hazy summer's day. Remember to start with the lightest colours when using coloured pencils. The drawing was done on medium cartridge paper (**fig. 121**).

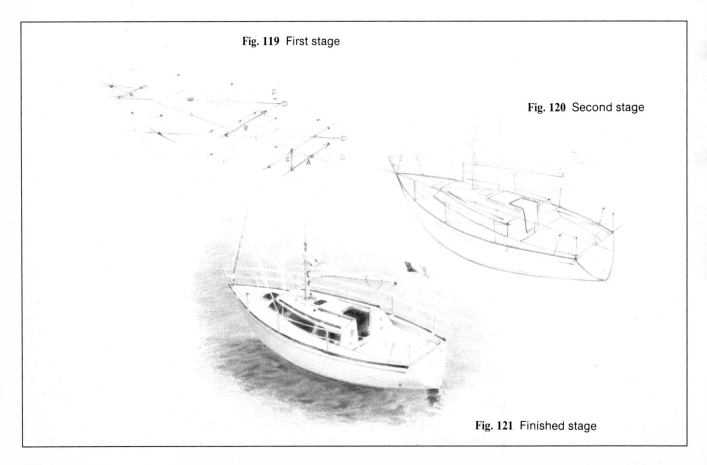

Fig. 119 First stage

Fig. 120 Second stage

Fig. 121 Finished stage

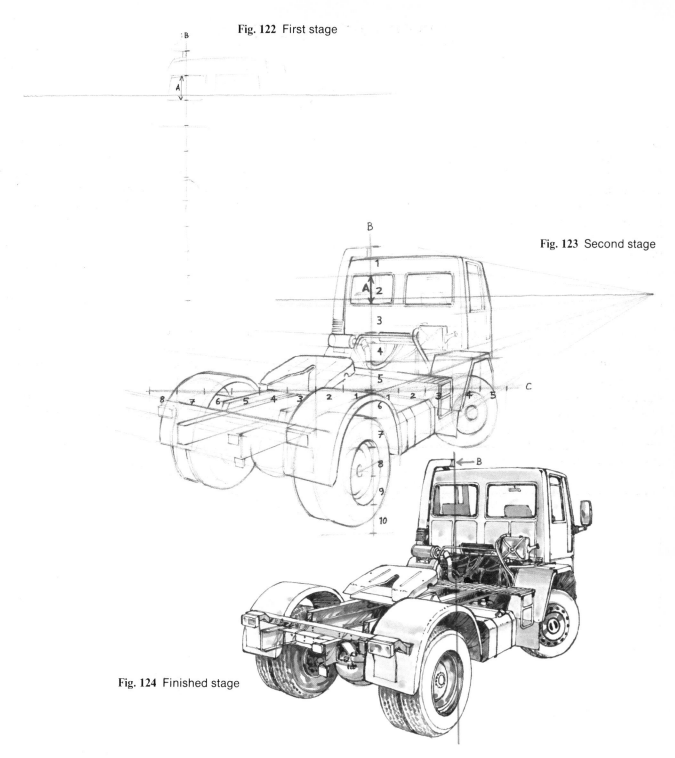

Fig. 122 First stage

Fig. 123 Second stage

Fig. 124 Finished stage

Fig. 124 is easier to deal with. Ignore all the details to begin with and concentrate on drawing the basic construction. First, draw in the eye level: notice how it cuts across near the base of the two rear windows and that the height of one of the windows would make a convenient measuring unit (**fig. 122, A**). Hold the pencil vertically at arm's length and line it up with the top of the cab. Draw in the line **B**. Use your measuring unit to divide this vertical line, which can be used as a guide to working out the proportions. For instance,

you will see that the objects at the back of the cab start three units from the top, and that the top of the right-hand rear mudguard is approximately five units down. Once you have established the position of the two mudguards you will be able to line them both up, and by continuing this line to the eye level you will establish the vanishing point. Then use this, with the measuring unit, to complete the basic drawing (**fig. 123**). I finished the drawing in pen and wash, using Daler-Rowney's Violet drawing ink (**fig. 124**).

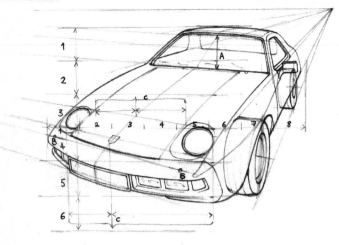

Fig. 125 First stage

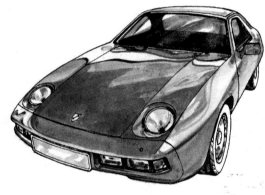

Fig. 126 Finished stage

Sports cars are another difficult subject. Like boats, they have very few, if any, straight lines. This makes it difficult for an artist to work out the perspective; but remember the rule of looking closely at your subject before starting to draw. Because a car is a precision, machine-made, symmetrical object, certain points each side of the vehicle can be used to provide the straight lines required. Notice, for example, the two small objects at the front (**fig. 125, B**). By joining the two you will get a straight line, just as you will by joining the two headlights and corners of the wind-screen. Remember that in a perspective view the centre line never divides an object into two equal parts. Look at the distances marked **C**. The half of the car furthest away from us occupies a smaller area than the nearer half.

Drawing becomes easier when it comes to the side of the car. By using the base line of the right and left side windows, along with the line at the bottom edge of the car and that of the wheels, it is possible to establish the vanishing point on the eye level. The height of the centre of the windscreen (**A**) was used as a measuring unit to determine the height and width of the car. When measuring you must always hold the pencil vertically (not diagonally despite the shape of the windscreen) with your arm fully extended in front of you (see page 14). Black watercolour was used as a wash to complete the drawing.

Working out the perspective of the removal van (**fig. 127**) was very simple, for there were so many straight lines to use. Notice, however, how because of the height of the van the upright lines slope slightly inwards (**A**). You can also see, once more, that the centre line does not divide the front into two equal parts (**C** and **D**).

These drawings may look very complicated, but once you have mastered the basic techniques covered in this book, you should be able to tackle any drawing confidently.

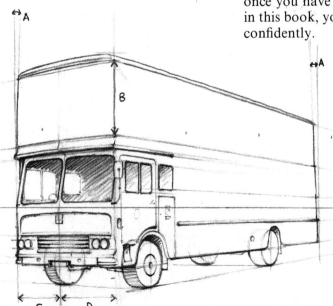

Fig. 127